IMAGES
of America

EAST
LONGMEADOW

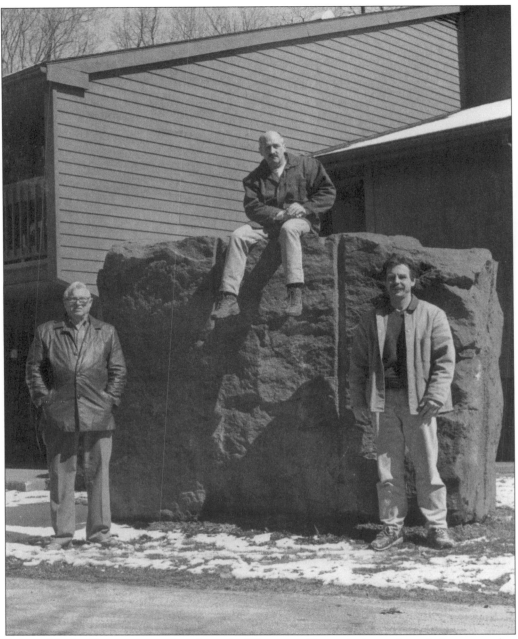

A large block of brownstone taken from the Worcester Quarry is shown here. It is now used as a decoration at the Brownstone Gardens. This block was a second-grade stone, so it was never used in construction. From left to right are author Jack Hess and his assistants, Wayne Bickley and Bruce Moore, all of the East Longmeadow Historical Commission.

IMAGES
of America

EAST
LONGMEADOW

Jack Y. Hess

ARCADIA

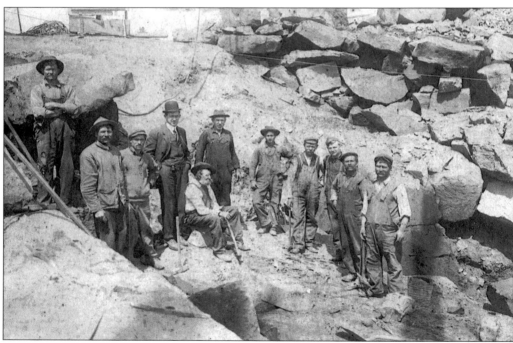

Workers of the Norcross Brothers Stone Company pose in the quarry with their appropriate tools. The owner joined the group for this photograph. In the background, you can see the rubble that was a waste product until the workers reached solid stone. The building in the background held the winch to operate the cobbles on the derrick.

CONTENTS

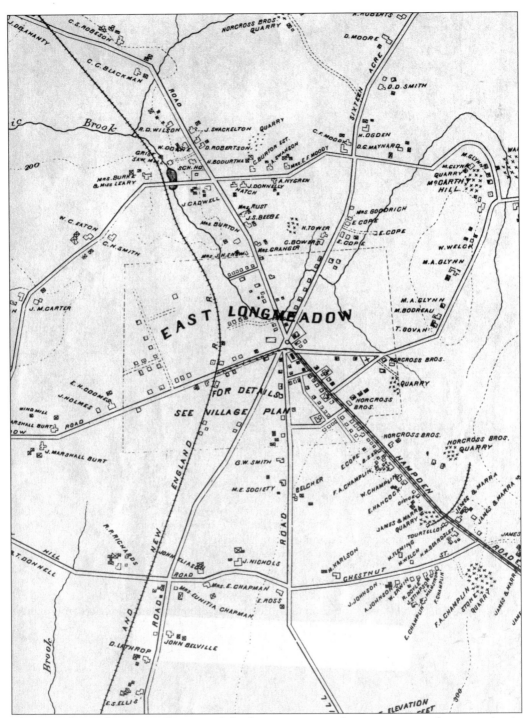

This map shows the center of town and the famous rotary with seven main roads converging in the center. It also shows the location of some of the sandstone quarries and the homes of the early settlers.

6

INTRODUCTION

In the 1800s, East Longmeadow was known as East Village, a community in Longmeadow, Massachusetts. The small village was made up primarily of farmers and a few shops. The farmers found outcroppings of sandstone on their property, which were used for the foundations of local homes and outbuildings. After the Civil War, the residents of East Village discussed becoming a town; they achieved their goal in 1894. In the meantime, the quarries grew to become a significant part of the local economy, and were taken over by professional construction and quarrying companies, including James & Marra of Springfield and the Norcross Brothers of Worcester. These companies put East Longmeadow on the map. Each company employed up to 300 men, mostly from Canada, as well as men from other areas with strong quarrying industries, including Portland, Maine, and parts of Connecticut.

The quarrying industry was strongest from the 1870s through 1900. Locally, the stone was used in the construction of many important buildings, including the U.S. Armory buildings, as well as their grinding wheels and the base of the iron fence that surrounds the armory complex. The railroad line came through town in 1876 and transported the stone to towns and cities across the United States. The railway had the additional benefit of providing rail service to area residents. In 1902, the Springfield Street Railroad extended its lines into the center of town, making East Longmeadow more accessible from Springfield.

Many homes were left empty after the crash of the quarrying industry around 1900, caused by the increasingly popular use of poured concrete and lighter stones for building. The industry had a revival when the McCormick Company of Holyoke came to town in the early 1930s and again in the 1960s to supply stone for additions to many of the buildings that had originally been built with brownstone. Unfortunately, due to the environmental impacts, the quarries where shut down once for the last time in 1972.

Today, East Longmeadow is largely a bedroom town for the city of Springfield. It has lost the small town flavor, and growing pains continue to make their way into this once rural community. In this book, we celebrate the historic quarry industry and the buildings in which the people of East Longmeadow lived and worked. This book has only covered a small part of this industry, and we hope it brings to light a glimpse of the town's history as we enter the 21st century.

ACKNOWLEDGMENTS

The building of this book was a fun project for me and was made especially easy by the close working relationship with Wayne Bickley and Bruce Moore, both members of the East Longmeadow Historical Commission. Thanks also, to my wife, Sheila, for her assistance in typing and putting up with my piles of pictures everywhere.

I would also like to thank the following people who offered the use of their photographs and other valued information: Bruce Moore, Wayne Bickley, Bill Speight, Jim and Sandy Davis, Mr. and Mrs. Emil Hahn Jr., Robert and Elaine Fisk, Keith Lindner, Armen Tashjian, Joseph F. Dilk, George and Mary Tracey, John Buckley, Mr. and Mrs. Harold Porter, Hugh Stebbins, Elizabeth and Lawrence Levine, Larry Gormally, Richard Clark, Ted and Maxine Hendrick, Valerie McQuellan, Stanley Krahala Jr., Marshall Hanson, Dick Brady, Edwin Pearson, Thomas and Gina Bergamini, Edward and Arlene Betterly, James and Jane Punderson, Chief P. Robert Wallace, Elaine Gleba, the Calabrese family, Jean Ouellette, Joyce Horner, Jean Ireland, Donald and Barbara Heenan, Robert and Jean Moore, Charles Bickley, Arnold Christianson, and Eleanor Turnberg.

I would also like to thank the following businesses for their contributions: Milton Bradley, American Saw & Manufacturing Company, Forbes Garden Mart, Kelly-Fradet Lumber Company, and Garelco Sales.

The files of the East Longmeadow Historical Commission, the Ashfield Historical Society, and the Howe Brothers Photo Company were all a great source of information. Thank you.

One

THE QUARRIES

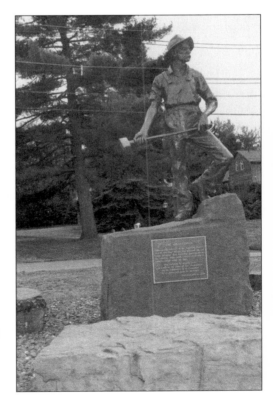

Our founding fathers started quarrying red and brown sandstone from over 50 quarries during the 1880s. Their work remains exhibited in noted buildings across the land. This statue, entitled *The Quarryman*, was erected at Center Hill Park in honor of the men who mined the sandstone. The sculpture was a gift to the Town of East Longmeadow by L. James and Janet K. McKnight on the celebration of the town centennial. It was dedicated on July 4, 1994.

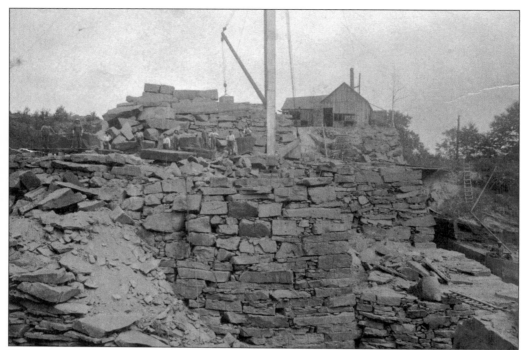

This photograph of an East Longmeadow quarry and quarry workers shows a good example of the walls of stone that were built to support cranes used to haul the large blocks of sandstone out of the quarry.

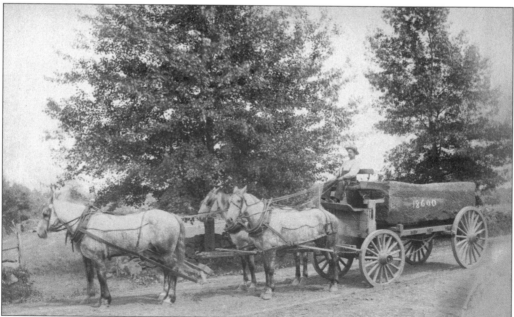

Clifford Smith is shown here on South Main Street at Chestnut Street, delivering stone from Taylor Quarry to the railroad station c. 1898. Due to the weight of the stone, it required two or three teams of horses and heavy-duty wagons for to carry the sandstone blocks.

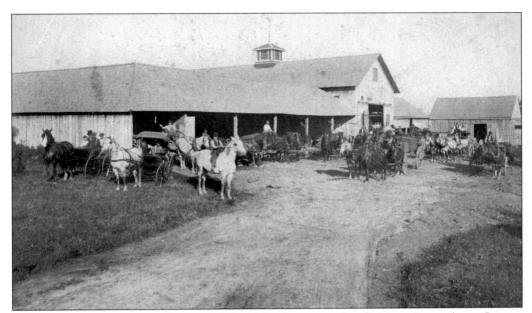

The barns of Frank Champlin stood behind his house on South Main Street (now Somers Road) in 1898. Frank had many teams of horses and wagons for hauling stone from the quarry to the finishing mill.

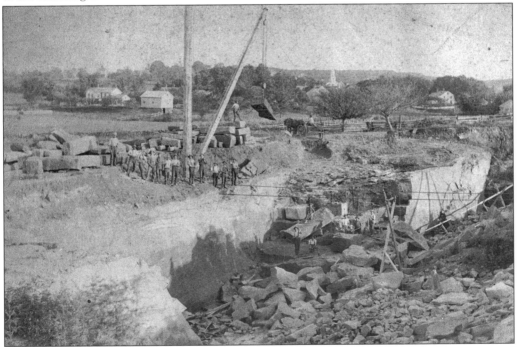

The Garfield Quarry workers, c. 1880, are shown hoisting a crane with a huge piece of sandstone. The proud workers are standing with their tools. The cables can be seen going across to the winch shed. The Methodist church is in the background. Speight Arden was later built on the site of this quarry.

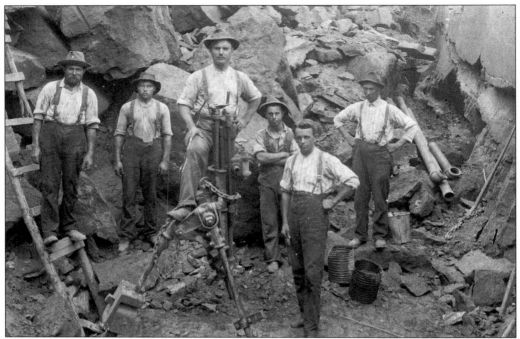

This c. 1901 showing the quarry workers was taken inside the quarry. Note the homemade ladder and pneumatic air drills for drilling into the rock. Empty black powder cans can be seen in the foreground.

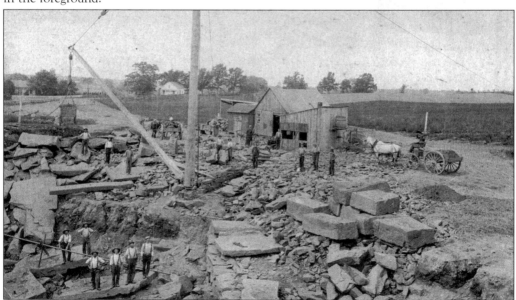

This c. 1880 photograph of the John Street Quarry shows workers hoisting a beam with a channel to let the cable go back to the winch in the shack. The proud quarry workers pose for this photograph. The North Main Street one-room schoolhouse is in the background. This building was moved to Center Park in April 1994 on the grounds where the original Center School was located.

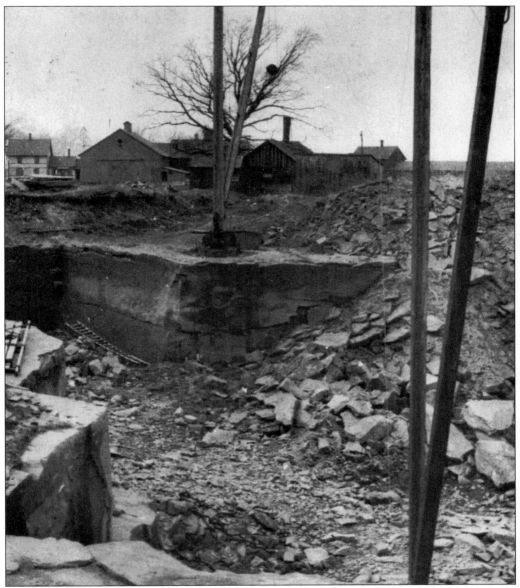

The Worcester Quarry on Somers Road, which was later filled in, is the present location of the town yard. The solid vein on sandstone can be seen here. The Norcross Brothers operated this quarry c. 1880. The Goodrich house and large barn stand in the background. They are both still standing today.

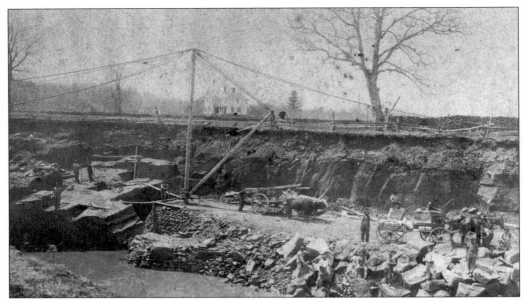

This c. 1875 photograph shows an early view of the Worcester Quarry on Somers Road. The quarry workers are shown posing with their tools of the trade and wagons for hauling the stone to the mill yards.

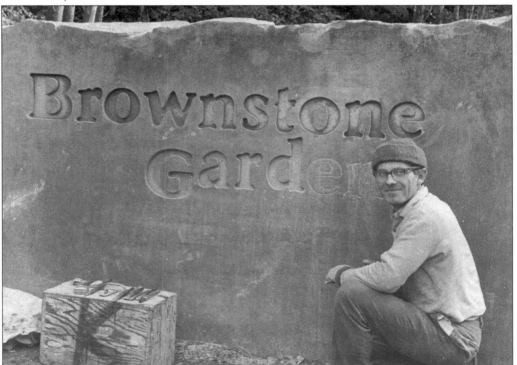

Christian Paine chisels *Brownstone Gardens* into a brownstone slab in this 1976 photograph. This is a 100-unit complex at 75 Pleasant Street, located next to the Brownstone Quarry. His chiseling tools are on top of the box.

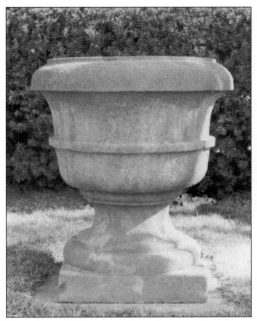

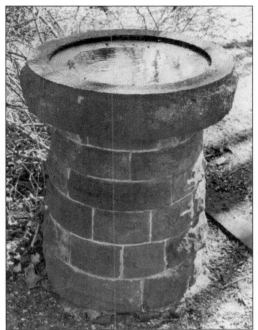

Napoleon White was a local carver for the Norcross Brothers Stone Company; White Street was named after his family. At the top left is a beautiful redstone urn made by White, which was originally located in St. Michael's Cemetery in Springfield. It now stands at Mrs. Skiffington's house at Somers Road and Callender Avenue. At the top right is one of White's birdbaths. At the right is a turn-of-the-century boot scraper made of East Longmeadow brownstone. The bottom photograph shows a bench carved by White. He did much of the fancy brownstone carving at Yale University. Many similar items were made at the stone yard on Somers Road.

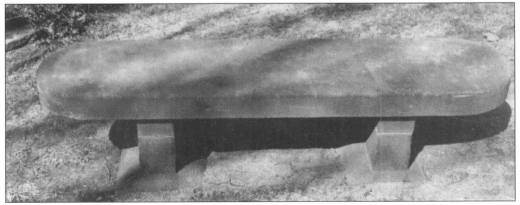

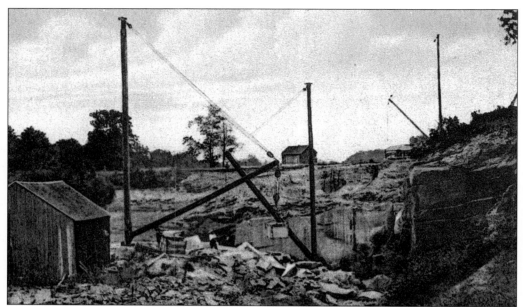

The Norcross Brothers Stone Company operated in town from late 1871 until the turn of the century. The company built the North Church at the end of Elliot Street in Springfield. The company expanded its holdings by purchasing seven more sandstone quarries in 1876. This expansion was partly motivated by the 1876 connection of the central railroad line into town with a station, which tied the quarries to larger markets and large pools of labor. The stone varied in color from dark red to medium brown and was an excellent building stone. Soon after 1876, the Norcross Brothers Stone Company built a stone cutting and dressing mill beside the tracks with horses to board and 100 or more workers. In 1918, the company sold approximately 150 acres and seven quarries. The company later purchased the Maynard Quarry of Elm Street.

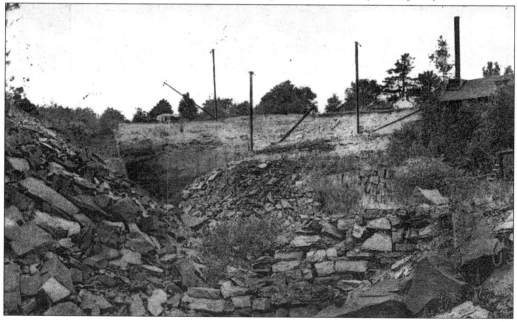

1883. PRICES 1883.

OF

LONGMEADOW FREE STONE,

DELIVERED ON CARS AT NEAREST STATION.

50 Cents per Ton, Extra, for Stone Delivered in Springfield.

			
Water Table, 5 inches thick, 7½ to 8 inches high,	per foot,	lineal,	$0 25
" 6 7½ to 8	"	"	30
" 7 7½ to 8	"	"	35
" 8 10	"	"	43
" 8 12	"	"	55
Window Stuff, 5 inches thick and under, 8 inches wide and under,	"	"	25
" 5 8 and under 12½ inches wide,	"	superficial,	35
Cellar Steps, 11 to 12 inches wide, 8 to 9 inches thick, promiscuous lengths,	"	lineal,	35
Coping, 10 inches wide, 5 inches thick and under,	"	"	25
" 12 5	"	"	30
" 14 5	"	"	35
" 16 5	"	"	42
" 18 5	"	"	48
" 20 5	"	"	55
" 22 5	"	"	62
" 24 5	"	"	70
Steps and Door Sills, 5 feet long and under, 1½ feet wide and under, 7 to 8 inches thick	"	superficial,	45
" " 7 2½ 7 to 8	"	"	50
" " 9 3½ 7 to 8	"	"	70
" " 11 4 7 to 8	"	"	90
Blocks, Posts, Lintels, &c., under 15 cubic feet,	"	cubic,	75
" " " 15 and under 25 feet,	"	"	85
" " " 25 and under 40,	"	"	95
[Forty feet and over price to be agreed.]			
All Monumental Stock, except Bases,	"	"	1 00
Bases, under 10 cubic feet,	"	"	90
" " 10 " and under 15,	"	"	1 20
" " 15 " " 25,	"	"	1 25
" " 25 " " 35,	"	"	1 30
" " 35 " Over, price to be agreed.			
Underpinning, under 2 feet high, 6 inches thick,	"	superficial,	35
" 2 and under 2½ feet high, 6 inches thick,	"	"	45
" 2½ 3 "	"	"	50
" 3 3½ "	"	"	60
" 3½ 4 "	"	"	85
Sockets, under 12 inches wide, 6 inches thick and under,	"	lineal,	25
" 12 and under 14 inches wide, 6 inches thick and under,	"	"	30
Stub Posts, 8 inches square and under, with ends jointed,	"	"	25
" 9 "	"	"	30
" 10 "	"	"	35
" 11 to 12 "	"	"	40
Promiscuous Blocks, under 40 cubic feet,	"	cubic,	50

Good, sound Stone, of the most durable kinds, suitable for Storehouses, Wharves, Bridges or Railroad Work, and all heavy Jobs of Hammered or Rock Work.

Also Rubble and Other Stone, Suitable for Church Work.

For Prices Apply at the Quarry. I assume No Risk for Damage to Stone by Frost after shipment.

M. A. GLYNN, East Longmeadow, Mass.

This price list for the year 1883 shows prices for Longmeadow Free Stone, which was owned by Michael A. Glynn. Glynn was postmaster from 1896 to 1899, when the post office was in the rear of Mr. Webster's drug store in the Hunn Block. In 1913, his son, Leo A. Glynn, became postmaster and moved the post office to the Robinson Block on Prospect Street. In 1918, he moved it to the Glynn home at William and South Main Streets. When he went off to war, his two sisters, Irene and Madeline, ran it until Leo's return. He then moved one of his barns from Maple Street to be used as a post office. A permanent building was finally built on Maple Street, which was used until 1959, when it was torn down to build Carlisle Hardware.

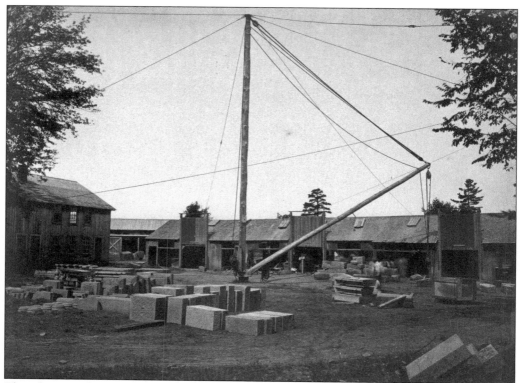

This photograph was taken in 1900 of the stone cutting yard at South Main Street. A variety of finished items are visible near the lower left of the image.

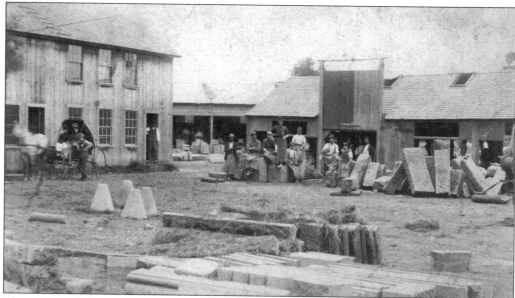

This image of the South Main Street stone-cutting yard and offices, c. 1900, shows finished stone drying prior to shipping.

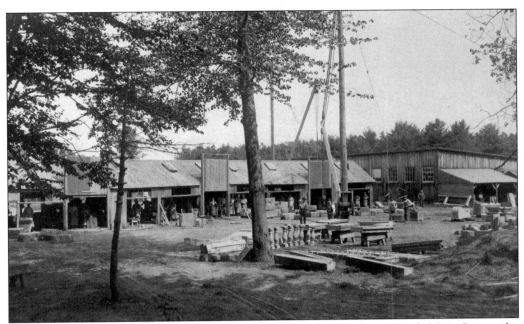

This was a typical day of work, c. 1900, at the stone-cutting sheds on South Main Street, the site of the present East Longmeadow Department of Public Works. Workers are seen with wooden mallets and steel chisels in hand.

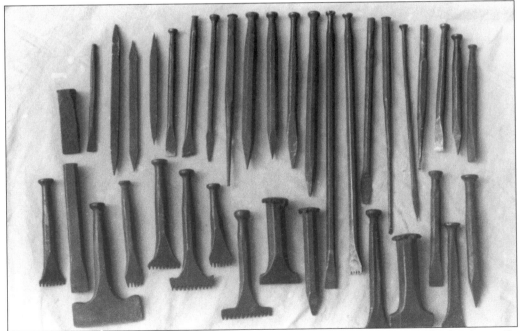

A variety of stone cutter's tools and chisels are shown here, including picks, wide chisels, cradle hammer points, and sawtooth chisels. Many are stamped with the workers names: O. Fox, F. Burton, N. White, F. Brown, L. Cooley, J.S. Beebe, McKenzie, Green, H. Ogden, J. Shaekey, and C. Kennedy.

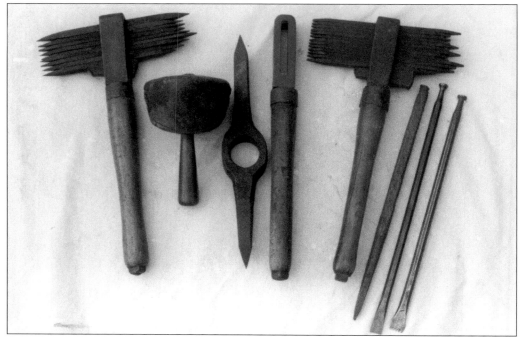

Some everyday quarry tools include crandling hammers for indenting tops of steps and topdressing stones, wooden mallets used for precise stone carving with steel chisels, and a small, sharp stone pickax.

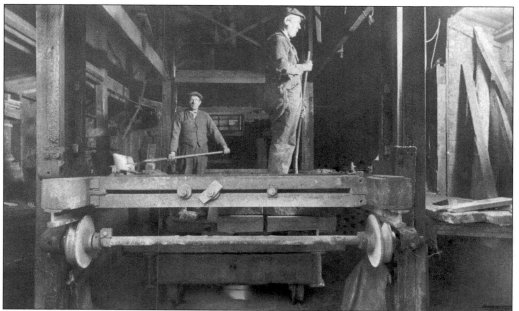

The old gang is sawing in the fabricating shed. The carriage allows the stone to be moved into the cutting process. Large wheels carry the wire that cut into the stone, traveling a long distance before returning to the stone, a process that helps to cool the wire.

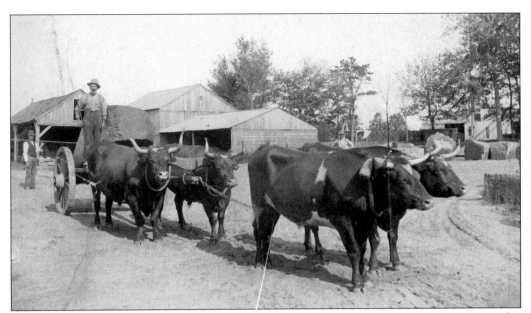

Ancient methods of hauling brownstone with oxen were used to pull the stone wagon. In this c. 1900 view, the driver is George Patrick with his team in the yards of the Taylor Quarry. The barns for these wagons and oxen were located on the site of the present transformer house of the Massachusetts Electric Company and the highway department yards.

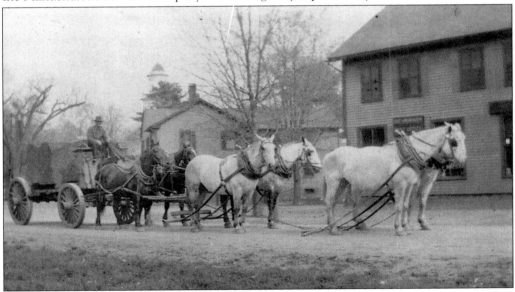

This c. 1895 scene shows one of the six horse hitches in front of the Hunn Block, as a large block of brownstone is hauled to the cutting mill off Maple Street. This was an everyday occurrence in the center of East Longmeadow when the quarries were in full operation. The Hunn Block contained several stores, including the post office. The steeple of the Congregational church is visible behind the wagon and the building housing the Henry Hall store. Frank Champlin built and owned many wagons for transporting the sandstone from the quarry to the finishing point.

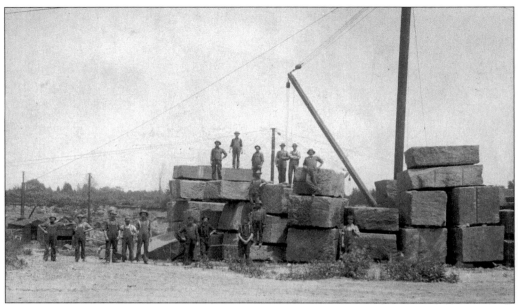

The Howe Brothers Photo Company of Ashfield took these photographs in 1901. Above, the blocks of sandstone are shown after being taken from the quarry. Below, Algot Carlson stands right of center in the back row, posing with the rest of his crew. Carlson was an expert in determining where the holes were drilled at exact intervals so when the holes were filled with black powder and ignited, the stone came out in perfect blocks. Frank Oscar Anderson, to the left of Carlson, was the father of the late Arthur W. Anderson, former town selectman, owner of a painting business for many years, and the last charter member of the East Longmeadow Lions Club.

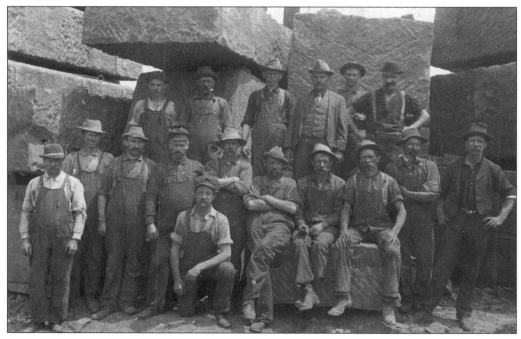

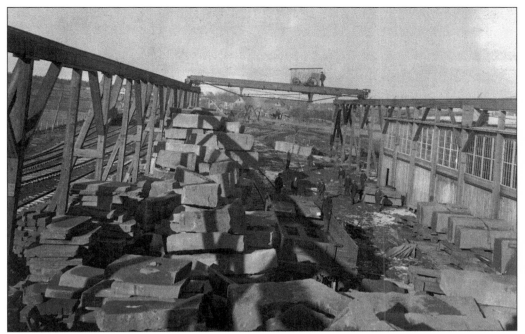

The Norcross Brothers finishing mill and loading crane was off Maple Street at the railroad tracks. Looking closely, one can see the railroad flat car being loaded with stone. The man standing on the crane gives one a sense of the size of the crane.

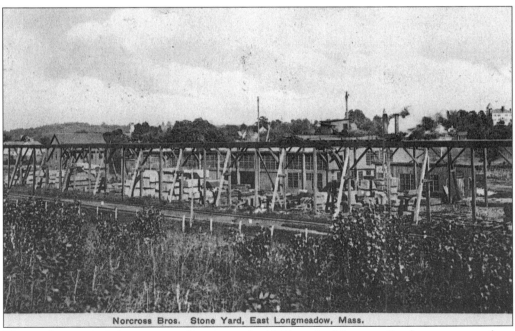

Norcross Bros. Stone Yard, East Longmeadow, Mass.

This early postcard shows a traveling crane in 1905 at the Norcross Brothers stone yard on Maple Street. The main office is to the left. The long building was the mill for processing stone. At the far upper right is Center School, a good half mile in the distance.

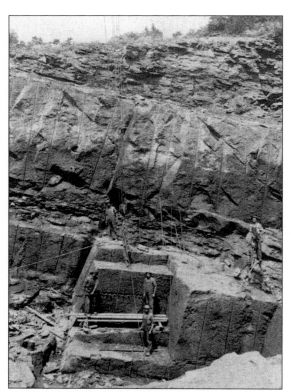

This c. 1900 photograph of the Worcester Quarry shows how the workers removed the larger blocks using only hand tools—not an easy task.

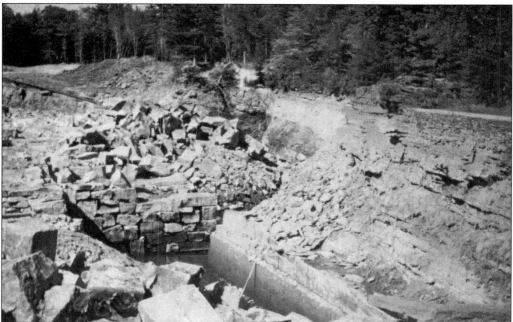

Redstone Lake was drained and the old Maynard Quarry bottom was exposed after many years underwater. In this 1969 photograph, overburden is being removed in the background. Quarrying operations were begun again by McCormick-Longmeadow Sandstone Company.

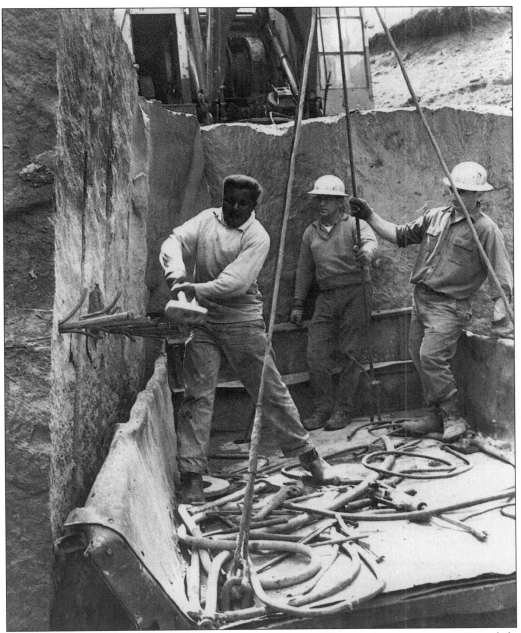

Rock drillers Arthur Butler and Michael Sears wait at Worcester Quarry, c. 1964, while Foreman Coley Brown drives a series of pins and feathers into the quarry stone. These pins are driven in until the block of stone splits.

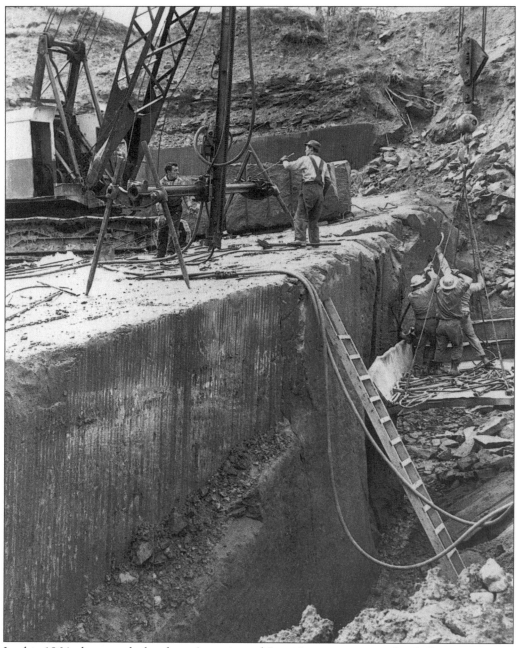

In this 1964 photograph, brothers Antonio and Luigi Larocea prepare the drilling equipment as Coley Brown, Arthur Butler, and Michael Sears work below in a truck bed suspended by a large crane.

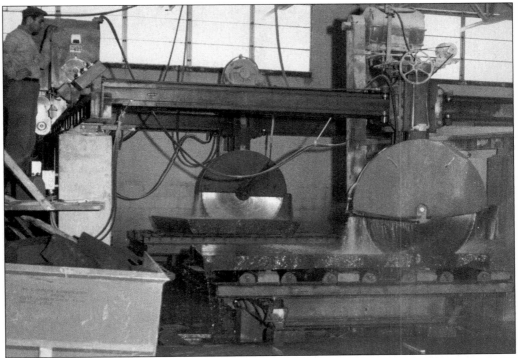

Rock saws are ready for operation at the McCormick-Longmeadow Stone Company on 41 Maple Street. The third major expansion of the stone processing plant was completed in 1969.

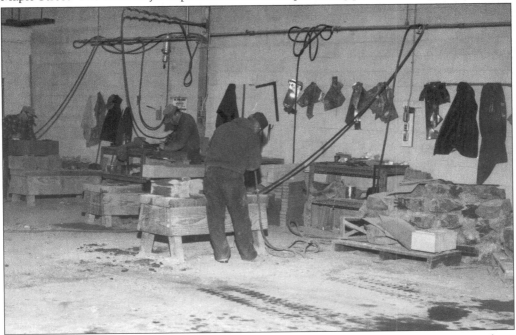

The McCormick-Longmeadow Stone Company on Maple Street, seen here *c.* 1960, was where the stone was cut to size and fabricated. Much of the work was done with air tools.

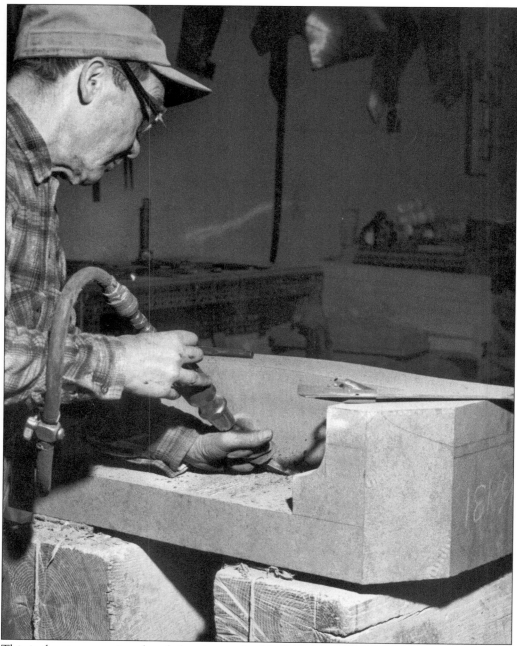

This is the stone-cutting shop belonging to the McCormick-Longmeadow Stone Company on Maple Street behind the Home Lumber Company. In this 1960 image, Leo Giancola appears to be working on a window well.

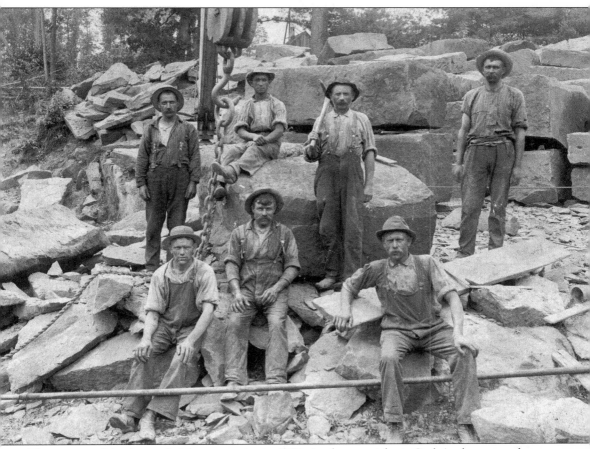

This is one of the James & Marra quarries in 1901 At the top right is Carl Anderson, and on the ledge is Maurice Carlson. The three workers in the front are Charles Rystedt, Eric Rundquist, and John Rystedt.

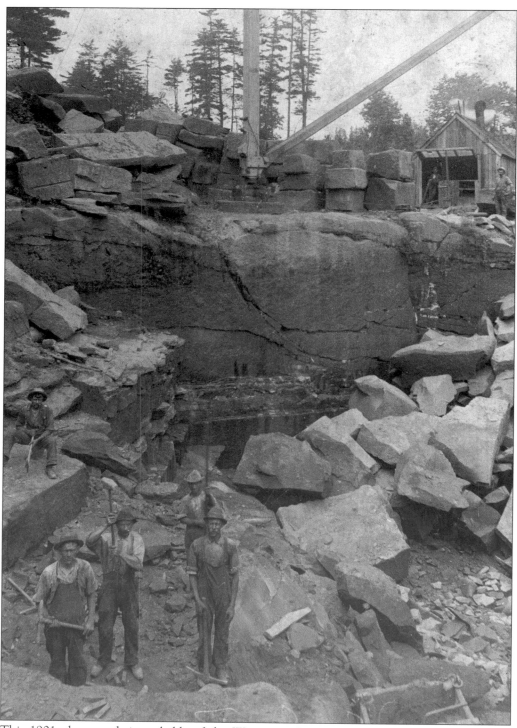

This 1901 photograph is probably of the Worcester Quarry on Somers Road. It shows men working at this very busy and successful quarry.

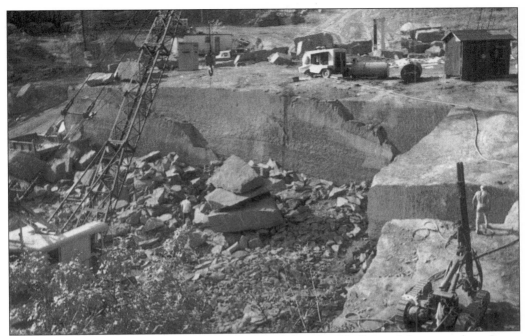

In 1970, the Maynard Quarry was reactivated by the McCormick-Longmeadow Stone Company to produce the famous red sandstone. The crane to the left is for moving the large pieces of stone. The air compressors and drilling rigs are also visible.

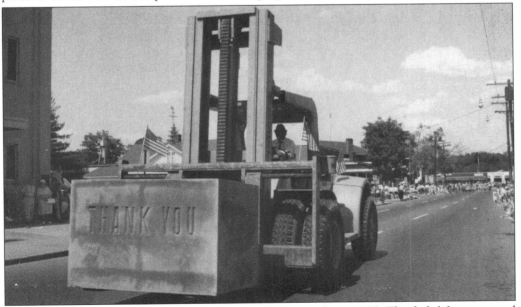

This photograph was taken during the Fourth of July parade in 1965. The fork lift was owned by the McCormick-Longmeadow Stone Company. The operator was the stone yard foreman, Coley Brown. The photograph was taken on Maple Street, just west of the center. The words *Thank You* were carved into a large sandstone block to thank the Town of East Longmeadow and its residents for their support.

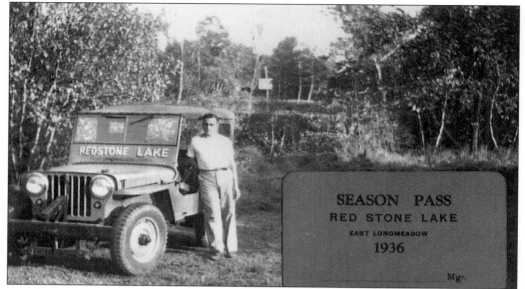

Standing next to his Jeep is Ralph Lindner, who ran the Redstone Lake swimming area for many years. This 1946 photograph shows his W/CJ2A Jeep, which was the first model available to the public after World War II. (Copyright Keith Lindner. Permission granted.)

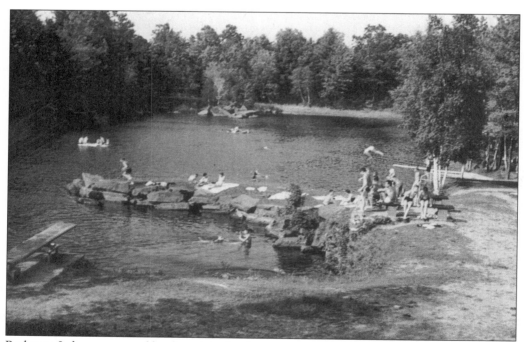

Redstone Lake was created by the original redstone quarry filling with water. Ralph Lindner ran the park. This was a swimming hole for many years, and was closed due to high liability insurance costs. Many pieces of redstone are still visible today. This photograph is from c. 1970. (Copyright Keith Lindner. Permission granted.)

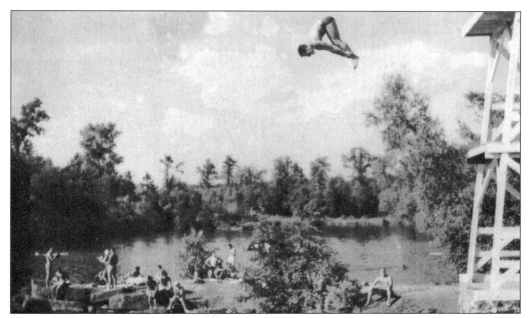

A graceful diver executes his dive off the high tower at Redstone Lake in 1946. Ralph Lindner and Donald Heenan built this new tower. (Copyright Keith Lindner. Permission granted.)

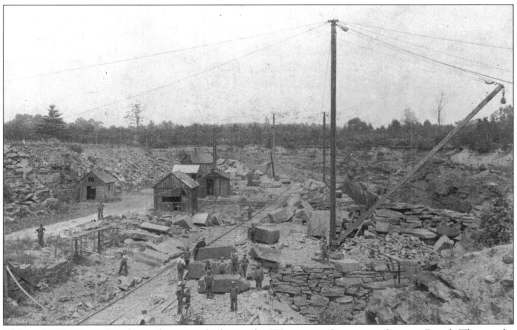

This c. 1901 Howe Brothers photograph shows the Worcester Quarry on Somers Road. The tracks were used to haul quarry rubble away from the work site; the rubble was then dumped elsewhere.

NORCROSS BROWNSTONE COMPANY,

QUARRIERS OF AND DEALERS IN

WORCESTER, MAYNARD AND KIBBE BROWNSTONE.

MAIN OFFICE,
WORCESTER, MASS.
TELEPHONE 520.

QUARRIES AT
EAST LONGMEADOW, MASS.

WORCESTER, MASS., July 15, 1903.

ALL AGREEMENTS CONTINGENT UPON CAR SUPPLY, STRIKES ACCIDENTS AND OTHER EVENTS BEYOND OUR CONTROL
QUOTATIONS ARE BASED ON PRESENT RATES OF FREIGHT AND SUBJECT TO CHANGE WITHOUT NOTICE

East Longmeadow Sandstone is quarried in two shades. East Longmeadow Brown and Kibbe Red

East Longmeadow
B R O W N

Estimates on Cut Work Promptly Given : : : :

JAMES & MARRA
PRODUCERS OF
SANDSTONE

Office and Quarries at East Longmeadow, Mass.
Telephone 4-2

Members
Master Builders' Association
116 Devonshire Street
Boston, Mass.

KIBBE RED

Orders by Wire, Mail or Phone Carefully Attended to Without Delay : : : : : : : : : :

Thomas Burton & Co.,
Successors to Charles Burton.

Wholesale and Retail Dealers in Longmeadow Freestone.

STONE SAWED TO DIMENSIONS AT SHORT NOTICE.

OFFICE · AND · QUARRIES.

East Longmeadow, Mass. Oct. 3 ___ 1892

D. D. DURANTAYE,

Wholesale and Retail Dealer in All Kinds of

FREESTONE AND GRANITE FOR BUILDING PURPOSES.

Estimates furnished to Architects and Builders on All Kinds of Stone Work.

Stone sawed to Dimensions at short notice.

Send Telegrams Via. Postal Telegraph Cable Co.
Connected by Long Distance Telephone.

OFFICE AND QUARRIES, *East Longmeadow, Mass,*

This is a collection of letterheads from different sandstone businesses located in town.

Two

CHURCHES AND
PARISH HOMES

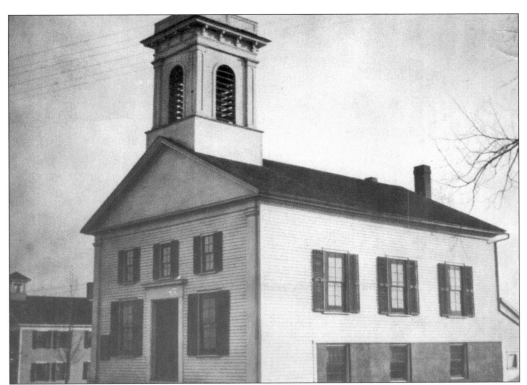

The First Baptist Church was located on the original Somers Road until 1954. In 1855, the congregation added a vestry, a tower, and a bell. In this c. 1910 view, the Baptist Village School is visible on the left.

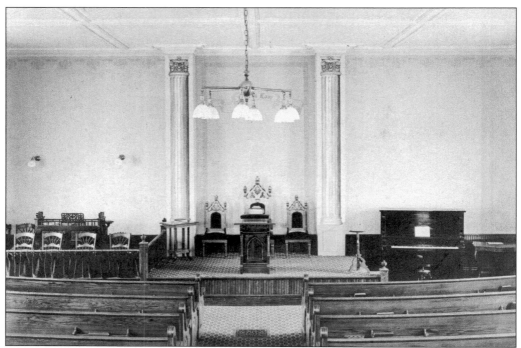

The sanctuary of the First Baptist Church is shown here in 1913 refurbished with new pews, carpet, and electric lights.

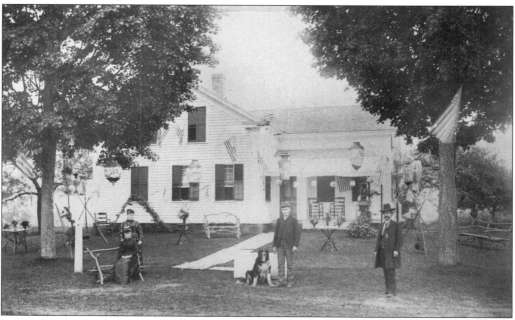

Richard Bennett was the pastor of the First Baptist Church from 1910 to 1914. He is shown here posing with his wife and children, Lillian and George. George became the pastor in 1932 and served for five years. The parsonage was located on Parker Street just south of Hamden Road.

This 1908 photograph shows a wedding in front of the Swedish Lutheran church, located on South Main Street (Somers Road).

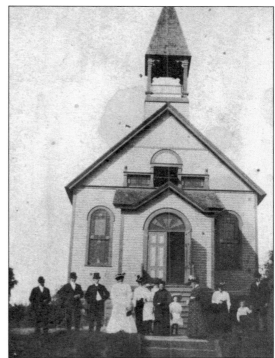

The St. Paul Lutheran church is shown with an addition that was built onto the front of the church in 1949. The addition was built by men from the church between July and December of that year.

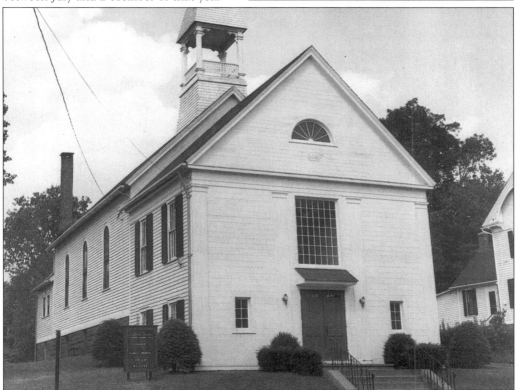

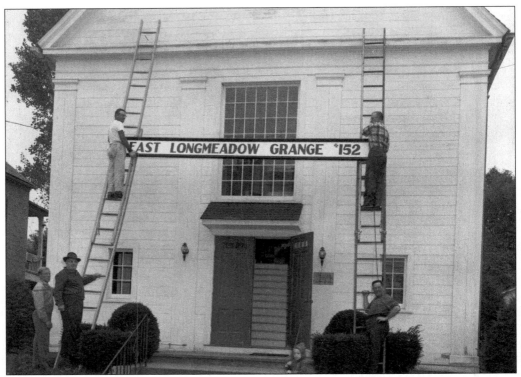

The East Longmeadow Grange bought the St. Paul Lutheran church on 30 Somers Road in 1961 for use as a Grange Hall.

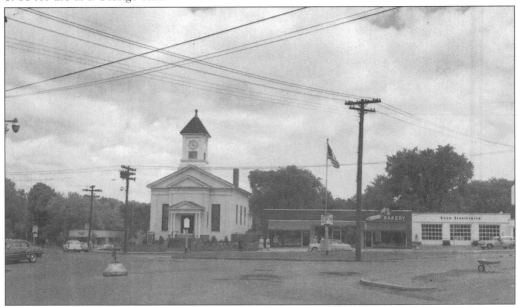

The East Longmeadow Methodist church, shown here in 1955, was built in 1853. It stood on Elm Street next to the old tavern on a lot bought by George Cooley for $300. Notice on the far left how people parked in front of the town hall.

The Shakers of Enfield, Connecticut, owned many acres of land in East Longmeadow. Part of the Ellis farm was bought from the Shakers. James Marra and Michael Glynn bough land off Pleasant Street near McCarthy hill from the Shakers. The Shakers practiced celibacy and a communal lifestyle. They were known for their fine food, and many townspeople enjoyed their hospitality. The railroad ran from East Longmeadow through their property. Shaker Road was so named because it ran from the center of town to their community.

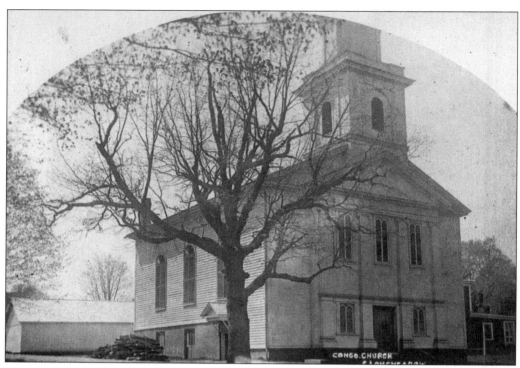

The Congregational church is shown here in 1909. The long shed was used for horse and buggy storage during church services. Notice the large pile of wood to the left of the tree. The W.J. Griswold Livery & Feed Stables stood to the right of the church.

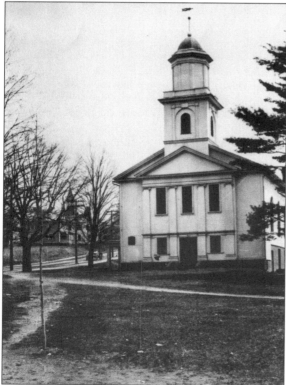

The Congregational church was a landmark from before the town was formed in 1894. The church was organized in 1827. In 1858, the building was moved down the hill to its present location facing the center. Edmund Pratt donated the land that the church occupies. It is shown here in a 1910 photograph.

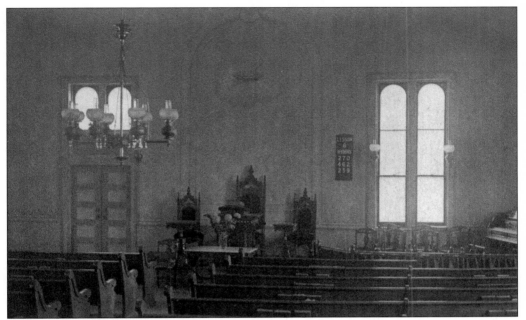

This photograph shows the inside of the Congregational church before it was moved to its current location in the center of town.

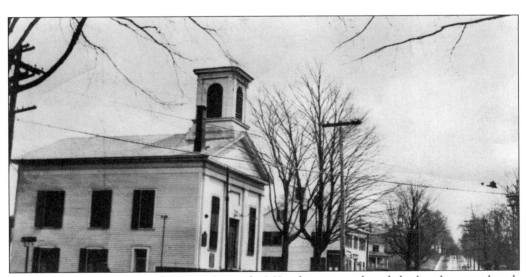

The Methodist church stood from 1853 until 1969, when it was demolished and a new church was built on Somers Road. Cormier's Tavern and the Fred Rowley house on the corner of Pleasant Street can also be seen in this 1917 photograph. This is now the location of Westbank.

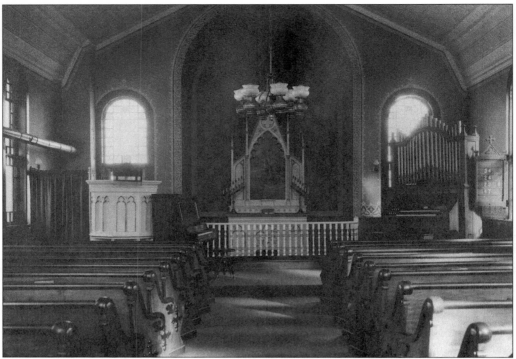

This is the interior of the Swedish Lutheran church just after it was built in 1891.

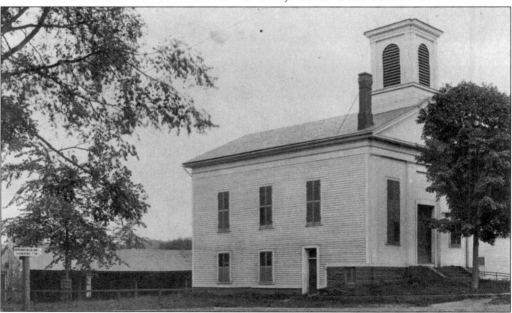

The Methodist church at the town's center stands on the corner of Elm Street. Sheds in the rear were for members to park their horse and wagon while attending church services. The sign on the corner reads, "Five Miles to Springfield" and "Seven Miles to Somers." This building was built in 1853 and sold in 1969. A new church building was erected on Somers Road and was completed in May 1970.

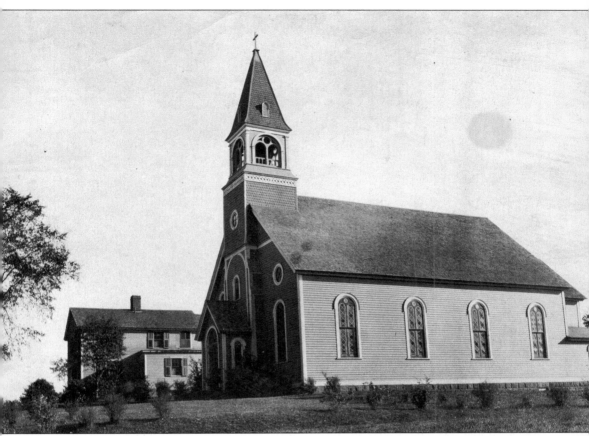

St. Michael's church and rectory is shown here on South Main Street (Somers Road). Services were held in East Village in the town hall until the church was built in 1887 with a seating capacity of over 300 people.

The Swedish Lutheran Church.

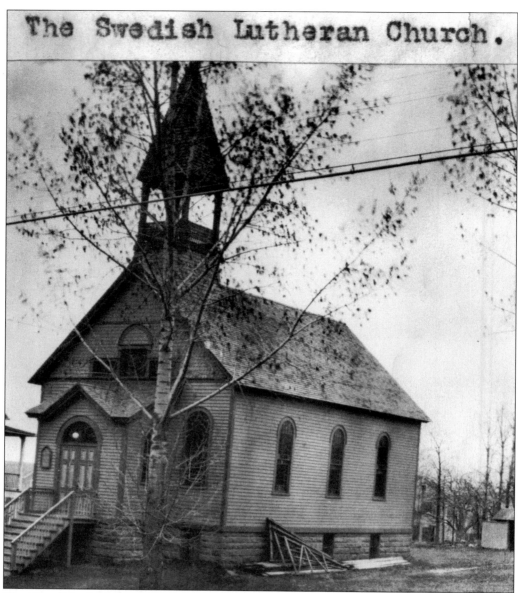

The Swedish Lutheran Church was originally called the Gustavus Adolphus Swedish Evangelical Lutheran Church. The church changed its name to the St. Paul Evangelical Lutheran Church in 1946. The church was built on the east side of Somers Road Hill in 1891 by the Scandinavian residents of East Longmeadow. The church basement was used for services until 1895, when the construction was completed. Most of the church men worked in the local quarries and helped build the church after hours. This photograph shows the church in 1917. The church was occupied by the Lutheran congregation until the early 1960s, when a new church was built on the corner of Elm Street and Mapleshade Avenue.

Three

HOUSES

This house and barn at 71 Somers Road stands at the corner of High Street. East Longmeadow maps from 1894 and 1912 show that G. Patrick owned it. The Howe Brothers took this photograph in 1901.

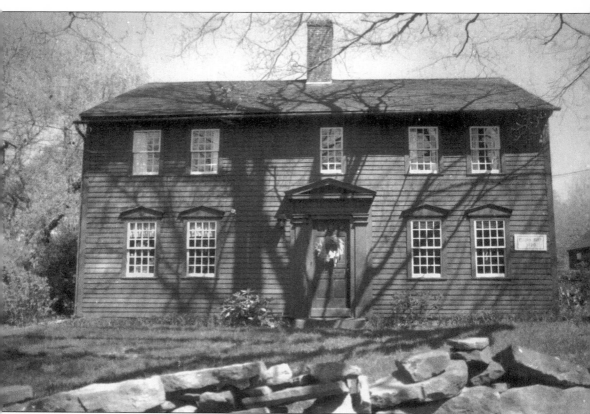

The Elijah Burt House, built in 1702 at 201 Chestnut Street was purchased in 1969 and thoroughly renovated for modern-day living without destroying the building's historical significance. The four original fireplaces (two of which were uncovered in its restoration) and two beehive ovens were once the only sources of heat and cooking. Originally a stagecoach stopover, the house features the original wide floorboards, paneled walls, and gunstock framing. The house contains a secret stairway leading to the cellar, which was said to have been used to hide runaway slaves during the Civil War. The house was the first local building accepted on the National Register of Historic Places.

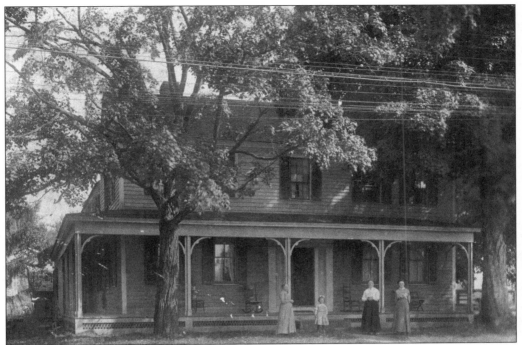

This 1890 photograph shows the old Pratt Homestead at the corner of Prospect and Williams Streets. The Pratt family gave some of their property to the Congregational Church. A parking lot was later built on the site of the house.

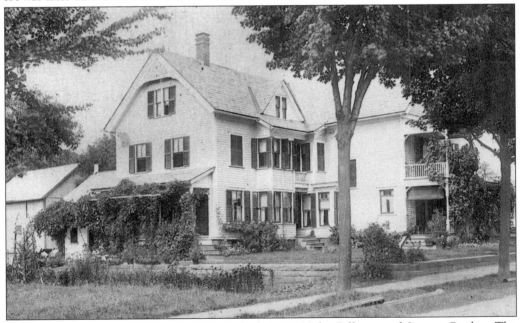

The Cooley House at 22 Elm Street was built in 1890 by Billings and Jennie Cooley. The Cooleys first came to Springfield in 1643 and settled in Longmeadow. Many of their descendants contributed to East Longmeadow's history. The house is seen here in 1980.

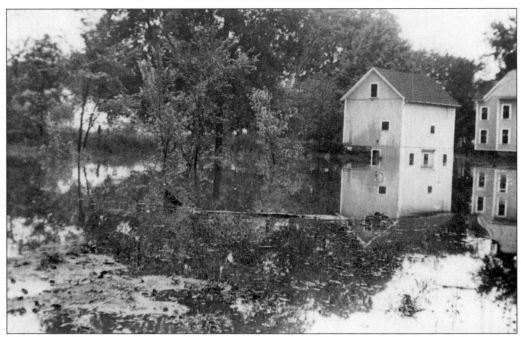

The Cooley House and barn are shown here after the 1938 hurricane. The Pecousic Brook rose an additional 12–15 feet above normal levels. This photograph was taken near the road's edge across from Rocky's Hardware parking lot.

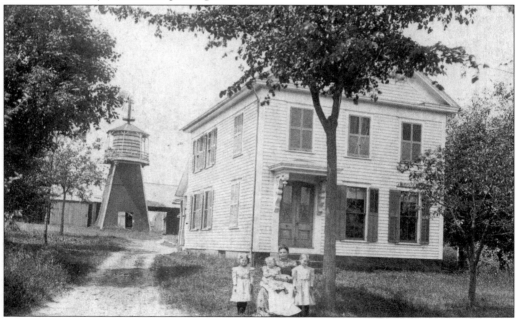

This is the house of Frank Champlin at 117 Somers Road. Pictured in 1901, from left to right, are Frank Champlin, Anna Chapin Champlin, Irena Champlin, Helen Champlin, and Blanche Chanche Champlin. At the time of publication, the owners of the house were Frank Champlin's grandson, Jim Davis, and Jim's wife, Sandy.

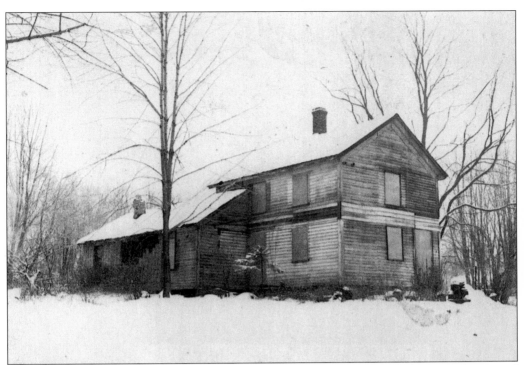

The old schoolhouse was originally the Fourth District School, once located at Main Street and Westwood Avenue. The school was built in 1792 and had just one room. In 1869, it was moved to 232 Prospect Street when it was raised and another floor was added. In 1965, it was remodeled again, adding a saltbox-style roof. The ell was turned and two rooms and a garage were added.

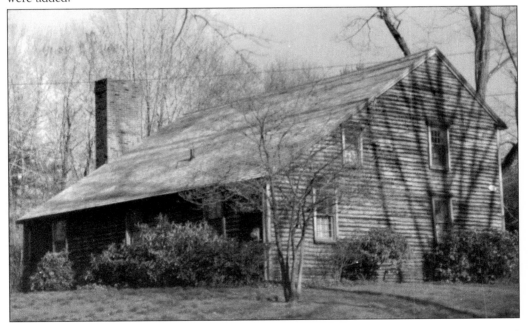

This house was built in 1858 at 368 Elm Street for the quarry workers to live in. Later, the Bilton family operated it as a farm. The ell was added sometime in the 1930s. The three-and-one-half acre farm also included a hen house and a vegetable stand. In 1984, it was completely renovated with the addition of a family room, a two-car garage, and a woodworking shop.

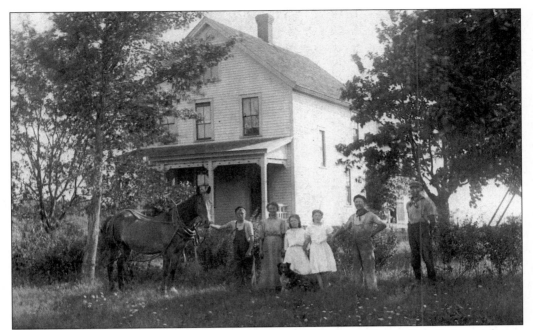

The Christianson family is pictured here in 1901 at 440 Prospect Street. From left to right are Harry, the son; Anna, the mother; Anna, a daughter who would marry Mark Bourgeoise; Minnie, a daughter; Charles, the father; and hired help. Harry Fisk, president of the Fisk Rubber Company, purchased the 75-acre farm in 1916 for $7,500. He moved the house to the corner of Prospect Street and Pease Road.

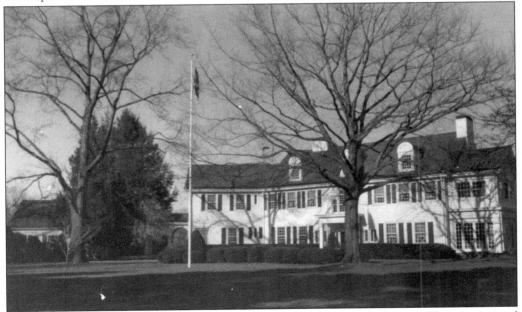

The Fisk estate at 440 Prospect Street was built for Harry George Fisk. In 2000, it was owned by the Sullivans. It included a working milk farm and orchard of more than 200 acres and was used by Fisk as a summer home.

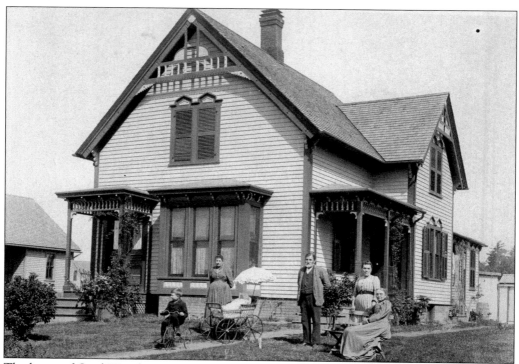

The home of Cyril Wood at 95 Maple Street is shown sometime before 1910. The bay window was later moved to the left side of the house, and the porch was removed from the right side.

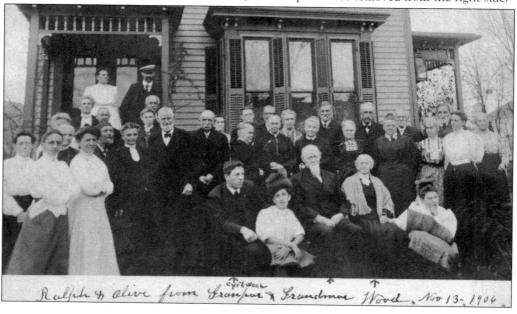

Ralph & Olive from Grampa & Grandma Wood, Nov 13- 1904

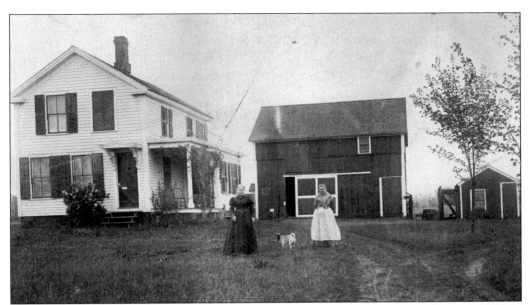

The Samuel Beebe house is shown here c. 1885 at the corner of Greenacre Lane and North Main Street.

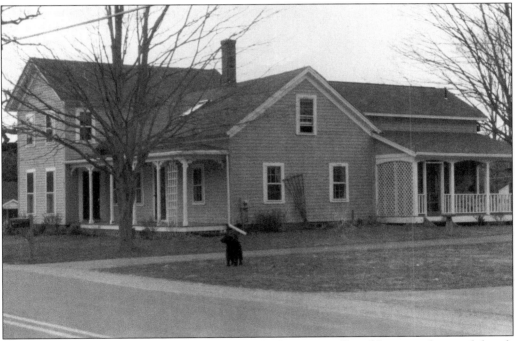

The ell of this home at 210 Hampden Road was built in 1812 of hand-hewn timbers with hand-made nails. Abel Pease added the upright part in 1863. The clapboard house had a casket door and a redstone foundation. In addition to the house, the property also contained a horse barn, a cow barn, and a two-story barn with a shed. It was originally a farm with 116 acres, but most of the land was sold in 1941 for a housing development. The Nooney family owned the house for many years.

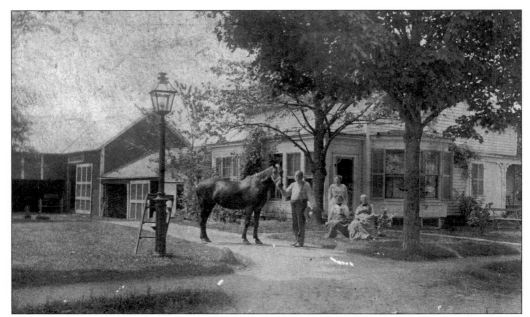

The Henry Hall and George S. Wood home was on Maple Street. It later became the office of Dr. Quinn. This is one of many photographs taken in town by the Howe Brothers in the early 1900s.

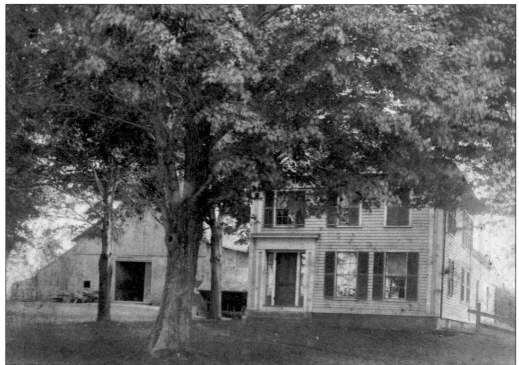

The McIntosh homestead stood at 1 Porter Road. It was later the home and farm of Patrick and Mary Landers. In 1963, it was demolished to build St. Mark's Episcopal church.

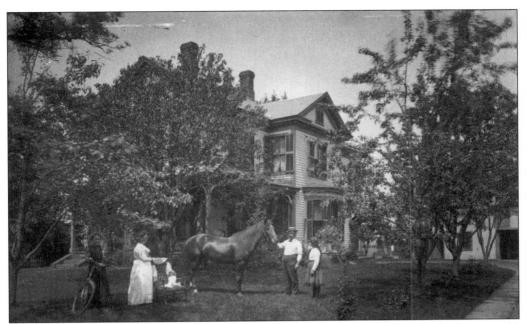

This 1901 photograph shows J.F. Norcross and his family. S. Tourtellet built the house at 89 Maple Street in 1870. Dr. Leon Feffer and his wife, Diana, lived here for many years. In 2000, the house was sold for commercial use.

This image shows the back of the J.F. Norcross house in 1980. J.F. Norcross was the son of James Norcross, who owned the quarry business in town.

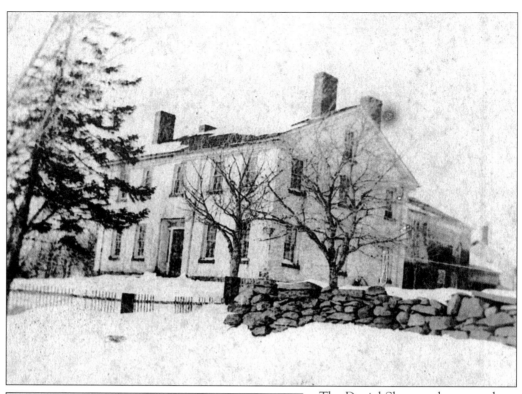

The Daniel Sherman homestead at 278 Porter Road burned down in the early 1900s. Daniel Porter's son, Sherman D. Porter (at left), was president of the Kibbe Candy Company. On his 50th wedding anniversary, he and his wife were killed at a train crossing in South Deerfield. His will left over $50,000 to the Town of East Longmeadow, which was used to build town roads.

The Bergeron family purchased this beautiful home and barn for $6,000 in 1943 after a bank foreclosure. It had 14 rooms with elegant woodwork throughout, including paneling in the dining room and a 36-foot-long living room. The stately willow trees can be seen here. The buildings were later sold to Mr. DeYoung, who used the barn as a furniture store, and the house was turned into a nursing home. The house was sold again and became the Willow Glen restaurant (below), which operated until it was torn down for space for a parking lot next to the Forastiere-Smith Funeral Home.

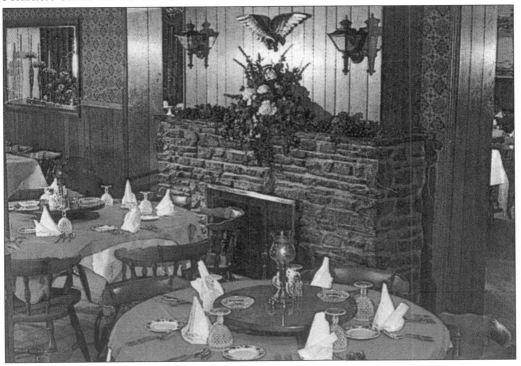

This beautiful house located at 164 Parker Street was built in 1829 as a farmhouse on 60 acres of land. At one time, it served as a boardinghouse for the quarry men, who worked in the town's read and brownstone operations.

This Colonial-style home at 245 Westwood Avenue was built on 60 acres in 1792 and is one of the few homes in town with an original coffin door. The living room had attractive paneling, hand-hewn beams, gunstock-type upright beams, a brick fireplace, and walls lined with brick. Portions of the property are now Franconia Golf Course and a housing development.

This modified saltbox-style home at 354 Elm Street dates back to c. 1810. It was originally owned by Clark Cooley Jr. Brownstone from the local quarry was used for the foundation, and a large slab of brownstone extends across the entire front of the house as a front porch.

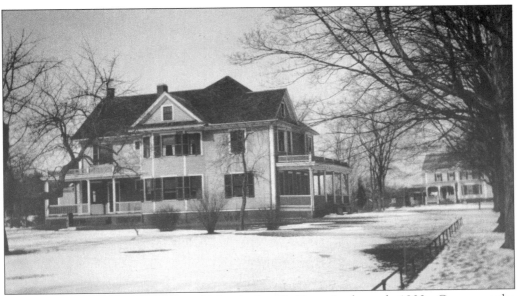

This house was the home of Mr. and Mrs. Arthur G. Crane in the early 1900s. Crane was the postmaster and later went on to serve in the Massachusetts Legislature. The house was demolished in 1976 to make room for Rocky's Hardware. The Cope home is in the background.

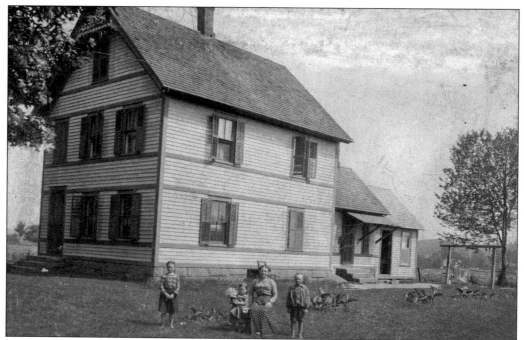

The Goodrich home stood at 70 Somers Road. Pictured here in 1901, from left to right, are Gladys Goodrich, Hazel Goodrich (with doll), Mary Goodrich, and Earl Goodrich. This house still stands today.

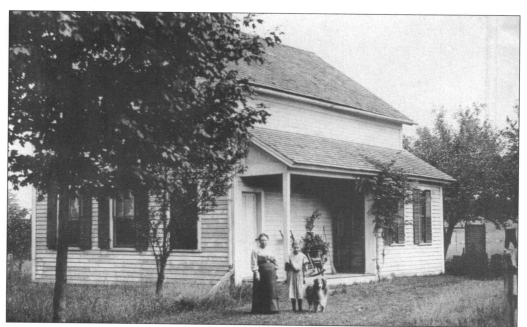

This home at 138 Meadowbrook Road was originally a barn owned by Daniel Dwight. It was moved to this site in the 1890s and converted to a residence. It was remodeled into a saltbox-style home in 1972.

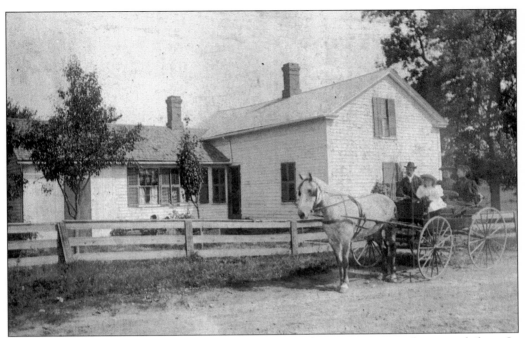

This house at 197 Elm Street was built in the 1840s and was once operated as a truck farm. In the 1990s, the house underwent extensive renovations.

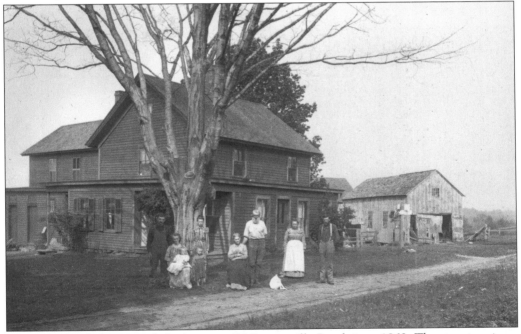

The same family has owned the house at 56 Somersville Road since 1862. The structure is on the 1831 town map. It was purchased by Henry J. Champlin in 1982; his five children—Frederick, Frank, Edgar, Winslow, and Elvia—were all raised in the house and attended school at Baptist Village.

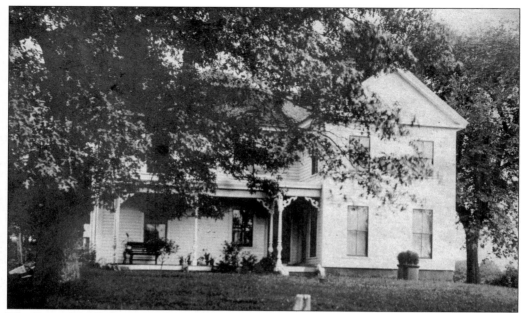

The Samuel Mills house is shown here, c. 1900, at 34 School Street. Samuel Mills was the custodian at Center School and the town hall. This house is now the earliest one on School Street. Two houses built on the street before this one were demolished for the St. Michael's Parish Hall parking lot.

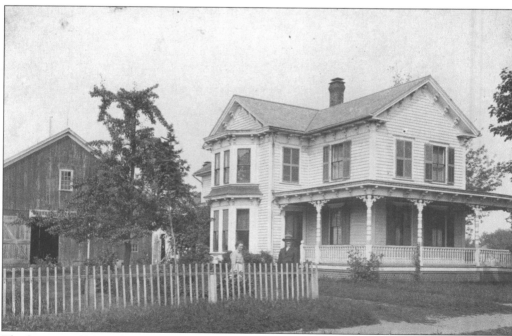

The house at 60 North Main Street was the home of Mr. and Mrs. Able Calkins in 1870, and Richard and Madeline Beebe from 1895 to 1958. The house is still in existence today.

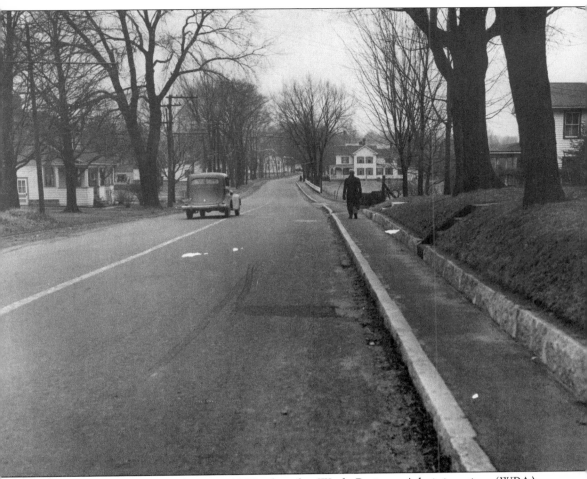

North Main Street is seen here in 1938 after the Work Projects Administration (WPA) installed curbs, sidewalks, and guard rails to protect the embankment and trees.

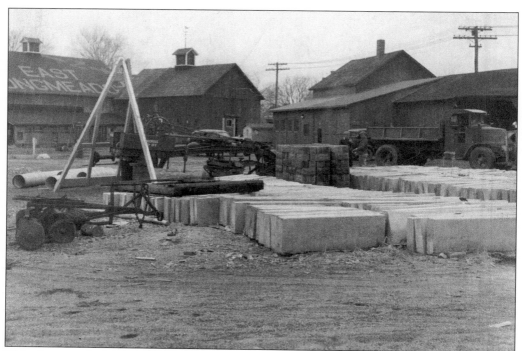

This photograph shows a WPA project on February 9, 1938, at the town yard off Somers Road. The barns were left from the Norcross Brothers Stone Company. Note the words *East Longmeadow* on the barn roof. The concrete curb piles seen here are ready for road projects.

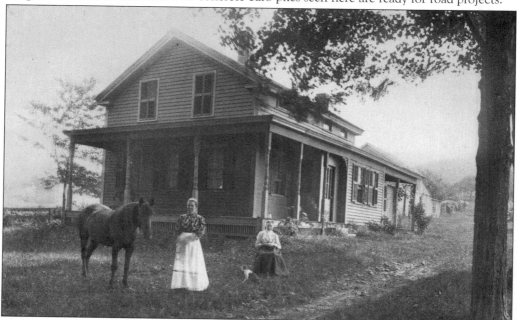

The house at 260 Shaker Road and the adjoining property were used for the construction of "the Bootery" and later the Academy of Dance. The house was built *c.* 1868 and demolished in the early 1990s.

The Glynn home stands at the top of Pleasant Street in this *c.* 1911 photograph. From left to right are Ivan Glynn, Lenora Glynn, her mother Eseldra M. Glynn, and Leo Glynn. Leo was the postmaster and a town selectman. Eseldra was a teacher and school principal.

This 1901 photograph shows the Edward J. Speight home on Hampden Road, now Somers Road. Pictured here are Mary T. Speight, Frank J. Speight, Hannah Brew Speight holding Leo M. Speight, Stephen L. Speight, and Edward B. Speight.

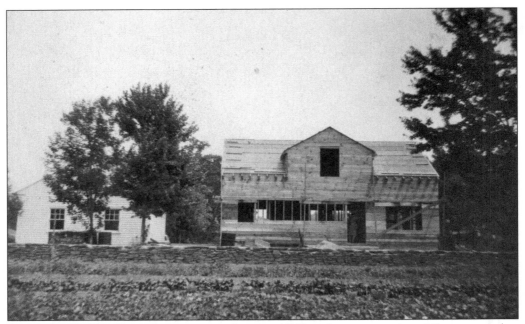

Sam Ryland's Elm Street house is seen here in 1948 under construction. Like many other people, Ryland built the garage first and then the house.

Shown is a front view of the house that Sam Ryland built in 1948. There was just enough room to get the cellar in before they hit the sandstone ledge.

David Jackson came to East Longmeadow from Scotland in 1904 and built this house at 48 Somers Road. The foundation and a fireplace were made of local redstone. He worked for the quarries all of his adult life.

This one-story cape on Shaker Road is one of the older homes in town. It was built in the late 1770s on a sandstone foundation.

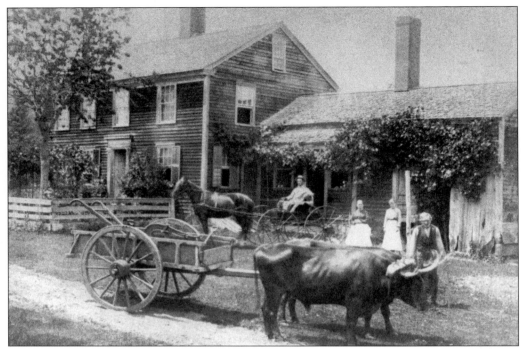

This photograph of 191 Pease Road was taken c. 1900. The owner, Marvin Pease, is shown sitting in the wagon in front of the house.

This is the original home of G.S. Wood at 95 Maple Street, built c. 1894.

Four

FIRE STATIONS

A horse cart stands in front of the first fire station, which was built in 1915 on the north side of Maple Street next to the center playground. It stood behind the town hall and operated by manpower. From left to right are Seabury Colby, Arthur Bourgeoise, and Earl Goodrich.

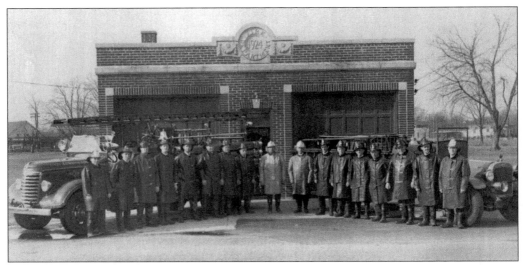

Fire chief Mark Bourgeoise and deputy chief Ray S. Jones are shown with members of the department in front of the old fire house on Shaker Road in 1952. Standing in front of the ladder truck are, from left to right, Capt. Henry Goodrich, Lt. Wrayburn Bourgeoise, Lylesford Dibble (driver), Frank Lacey, Michael Morrisino, Edwin Falk, Robert Turnberg, and Forest Goodrich. Bourgeoise and Jones are in the center. In front of the hose truck are Warren Kenyon, Edward Leahy, Alphonse Viens, Hubert Gagner, Arthur Bourgeoise (driver), Lt. Walden Southworth, and Capt. Alexander Richardson.

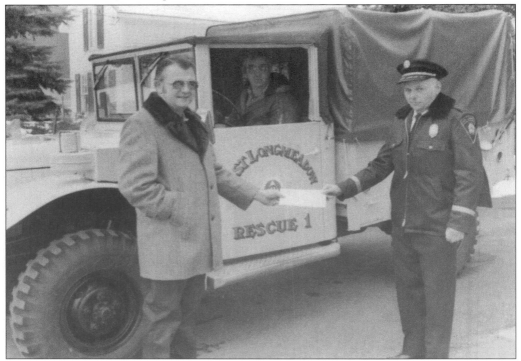

In 1981, King Lion James A. Davis presented a check from the Lions Club to Chief Forrest Goodrich. The money was to be used for the overhaul of the department's rescue truck.

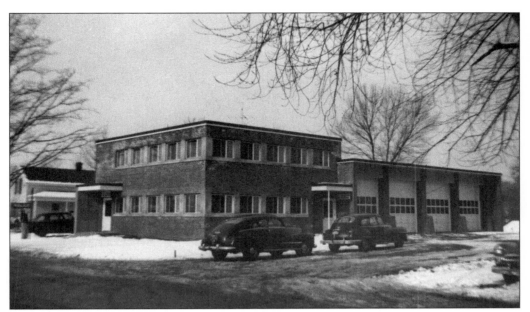

The third building was built in 1953. It was a combined fire station and police headquarters on Maple Street next to the library and town hall. The East Longmeadow Historical Commission headquarters is in the left background.

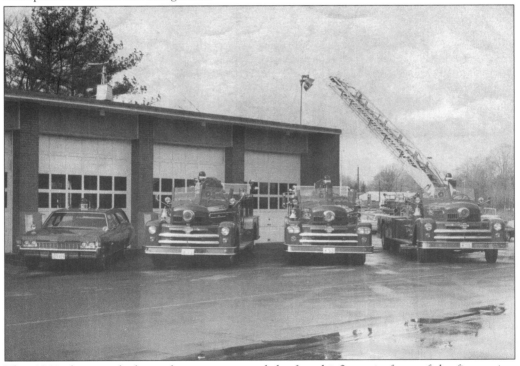

This 1969 photograph shows three pumpers and the fire chief's car in front of the fire station on Maple Street. The fire station is now located on Somers Road and this building is now used for bus repairs.

Sunset Farm East Longmeadow, Mass.
Luncheons-Dinners-Parties Permanent Guest
By Appointment Only Phone East Longmeadow - 7:

Sunset Farm at 268 Prospect Street is seen in this 1936 postcard.

Five
BUSINESSES

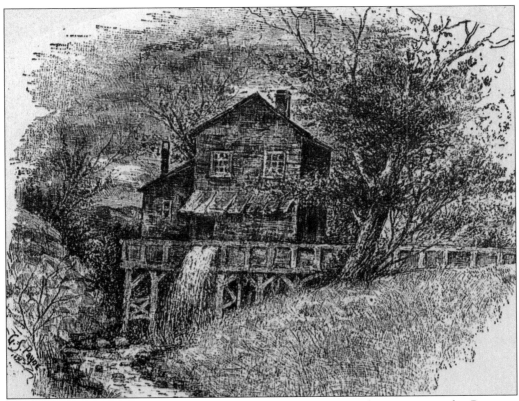

The old sawmill and gristmill known as Bodurtha's Mill was built in 1820 on the Pecousic Brook, north of Westwood Avenue and east of the railroad tracks.

Bodurtha's Mill is seen here in an 1887 photograph looking north from the bridge near the railroad tracks on East Street, now Westwood Avenue. It was originally built by local farmers who raised corn, wheat, and oats. It was later owned by William Vining, who used it as a saw mill. It was then owned by Henry Bodurtha, who ran it for more than 30 years, and then by Frank Hewlett. The mill had the largest overshot wheel in this part of New England. It burned down on July 3, 1906.

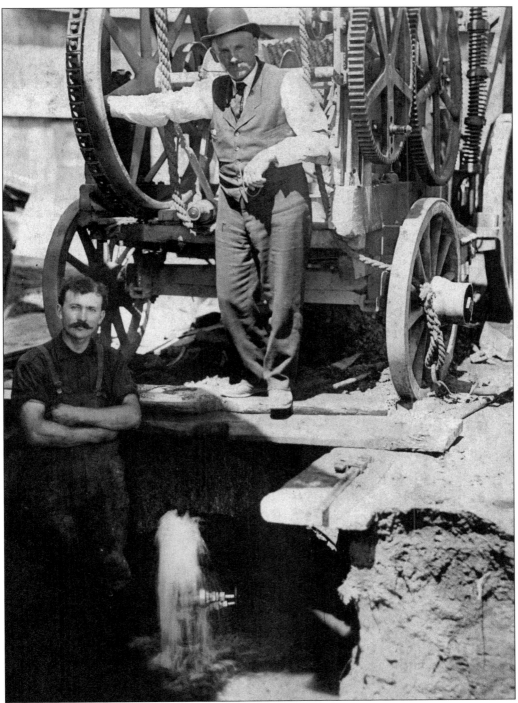

Frank A. Champlin went into the artesian well business after the quarry business came to a halt. Previously, he had many horses and wagons to deliver sandstone from the quarries to mills for processing. Champlin is shown here (wearing hat) standing next to his drilling machine.

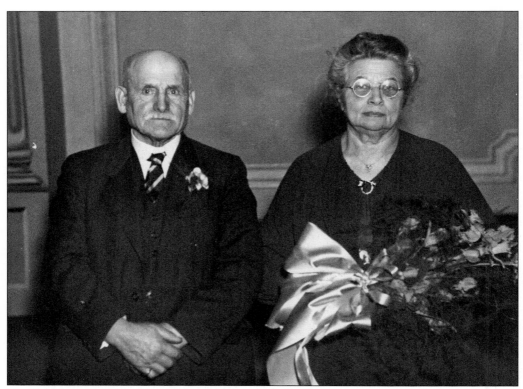

Frank and Anna Champlin celebrated their 50th wedding anniversary on January 31, 1936. Frank ran a transportation business hauling sandstone from the quarries to the finishing mill. When the quarries were shut down, he went into the well drilling business; he was a successful businessman all his life.

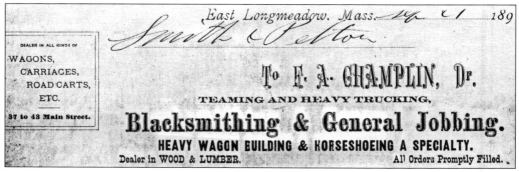

A NOTABLE ACHIEVEMENT

The Man

During the year 1911 I have drilled 138 Wells in Massachusetts, New Hampshire and Connecticut.

In addition to above have drilled 42 Test Holes.

These Wells vary
in depth from 41 to 606 ft.
yielding from
1 to 160 gallons
per minute

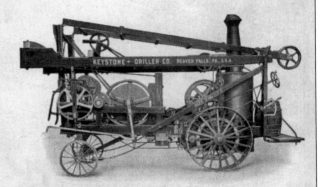

The Machine

The Result

In 1910 10 Flowing Artesian Wells each approximating 125 feet in depth were driven at Zylonite near Hoosac Tunnel, showing a capacity of 1000 gallons per minute.

F. A. CHAMPLIN
EAST LONGMEADOW, MASS.
Artesian Wells for Water Supply

This advertisement ran in *Western New England Magazine*, which was published for four years in the 1912 era.

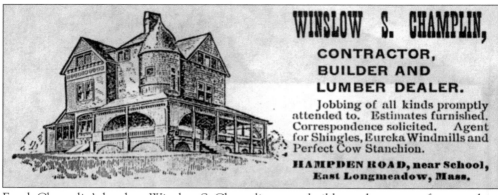

WINSLOW S. CHAMPLIN,

**CONTRACTOR,
BUILDER AND
LUMBER DEALER.**

Jobbing of all kinds promptly attended to. Estimates furnished. Correspondence solicited. Agent for Shingles, Eureka Windmills and Perfect Cow Stanchion.

**HAMPDEN ROAD, near School,
East Longmeadow, Mass.**

Frank Champlin's brother, Winslow S. Champlin, was a builder and carpenter for many houses in town. He was also a local agent for Eureka windmills, tanks, and pumps, and a dealer in lumber, shingles, and galvanized eaves, troughs, and cow stanchions.

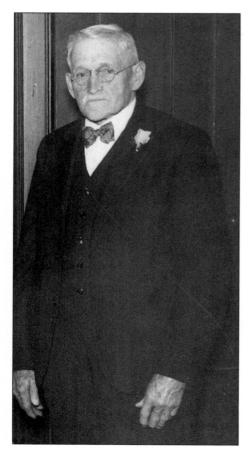

Winslow S. Champlin is shown in this 1937 photograph.

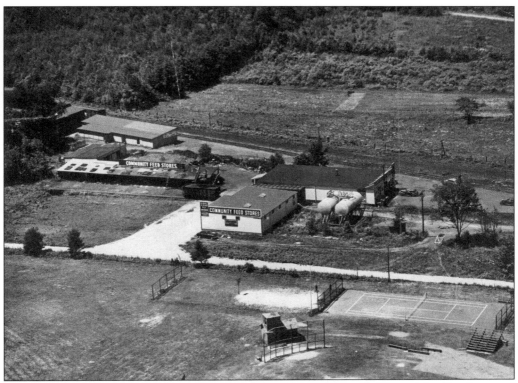

The Community Feed Store has been in operation since 1932 by the Rintoul family. A second store is located in Easthampton. The Forest Product Company, a lumber retailer, is the farthest building away on the upper left side of this c. 1950s photograph.

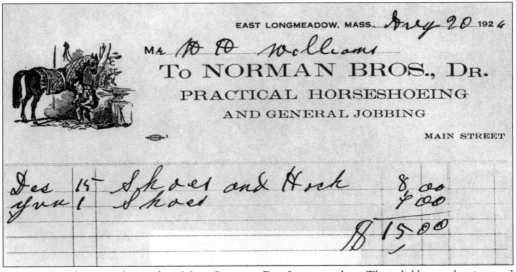

EAST LONGMEADOW, MASS. Aug 20 1924

Mr B B Williams

To NORMAN BROS., DR.

PRACTICAL HORSESHOEING

AND GENERAL JOBBING

MAIN STREET

Dec 15 Shoes and Hock — 8 00
Jun 1 Shoes — 7 00

$ 15 00

Norman Brothers was located on Main Street in East Longmeadow. They did horse shoeing and general jobbing for area residents. This was a bill for work done for W.H. Williams of Moss Rose Farm on Prospect Street, just north of the Connecticut state line in East Longmeadow.

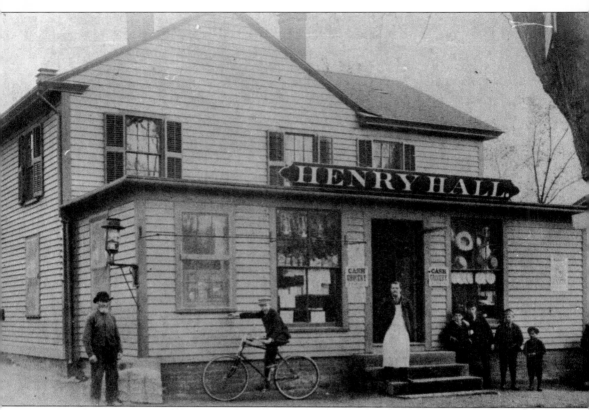

The Center Store, c. 1890, was originally a homestead. It was converted to a store and post office *c.* 1860. Cortis Russell was the first postmaster and storekeeper. In 1881, Russell sold the property to Henry Hall. His son, William H. Hall, continued to run it into the 1890s. The Hall family operated the store until July 1906, when it was leased to Charles Leon Cooley, who ran it until 1915. He sold the business to Adella Hall Wood's husband, George S. Wood, who operated it until 1938. Alline Barrett purchased it from Wood and ran a dry goods shop until 1948, when she sold it to Lewis Dunbar and John Fitzgerald. In 1948, they added a series of shops along Shaker Road. In the early 1990s, the SkiHaus expanded its operations into the Center Store building.

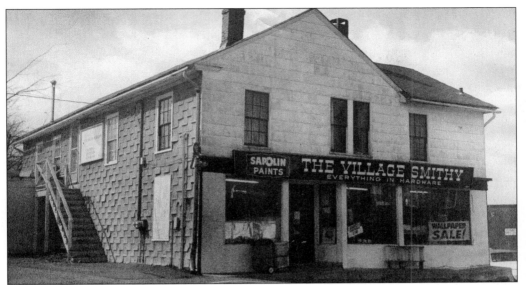

From 1949 to 1962, the Center Store was used as a hardware store by Sanford and Luella Nooney, known as Nooney's Hardware. Sanford Nooney was involved in town politics for many years. In 1963, Robert and Ester Smith purchased the store and changed the name to the Village Smithy. In 1979, the buildings were sold, and the SkiHaus opened for business. The original store was used for the Flower Stall and Eve's Antiques. The store is seen here in a July 1974 photograph.

The interior of the Center Store is shown here in 1927. In 1881, Henry Hall bought the store and moved in with his family. The Hall family continued to operate the store until July 1906, when it was leased to Charles Leon Cooley for $100 a year, to be paid in equal monthly installments. Henry Hall died in 1908.

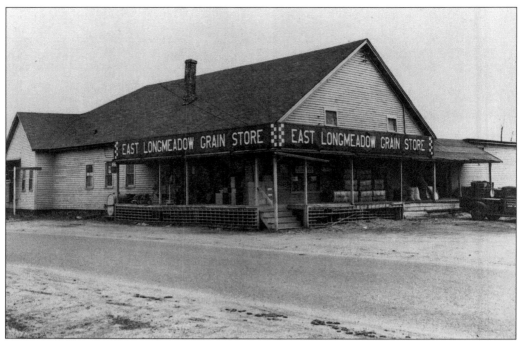

The East Longmeadow Grain Store was located next to the railroad tracks on Maple Street. According to historical records, the store dates back to 1888, when John H. Whitaker built a 25-foot by 40-foot structure for the sale of grain and coal. The building was enlarged twice over the years. The business changed hands several times, lastly to A.W. Brown when the old landmark was torn down on November 14, 1996, to make way for a Dunkin Donuts.

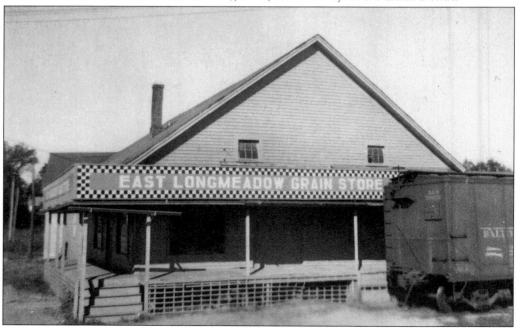

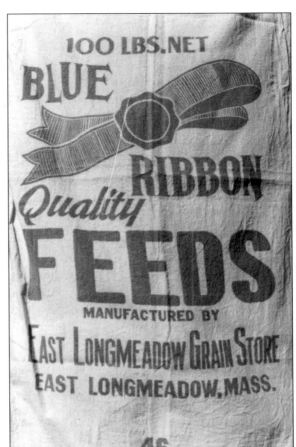

Deane Clark and Joe Cady owned the Checkerboard Grain Store, c. 1945, at the railroad siding on Maple Street. The original 25-foot by 40-foot building was built in 1888. On May 1, 1899, Frank H. Whitaker bought the property. As business grew, a coal pocket was built to hold several car loads of heating fuel.

FRANK H. WHITAKER,

DEALER IN

COAL,

Flour, Grain, Feed, Fertilizers, Etc., Etc.

EAST LONGMEADOW, MASS.

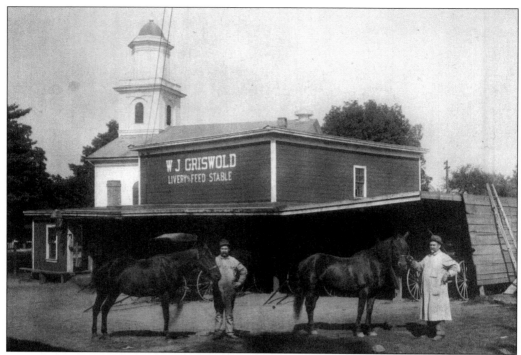

The W.J. Griswold Livery & Feed Stable is seen here in 1900. The man to the right is Ira J. Griswold. The building burned in 1908, and the other structures were torn down when the Leavitt automobile parts business was moved to Maple Street. Part of the Congregational church can be seen in the background.

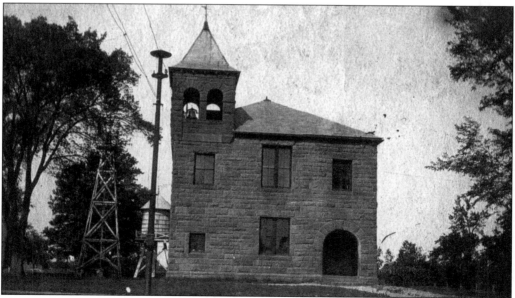

This 1910 photograph shows the town hall, which was built in 1882. A windmill and water tower can be seen to the left of the building. The large pole was used for electricity to operate the trolleys.

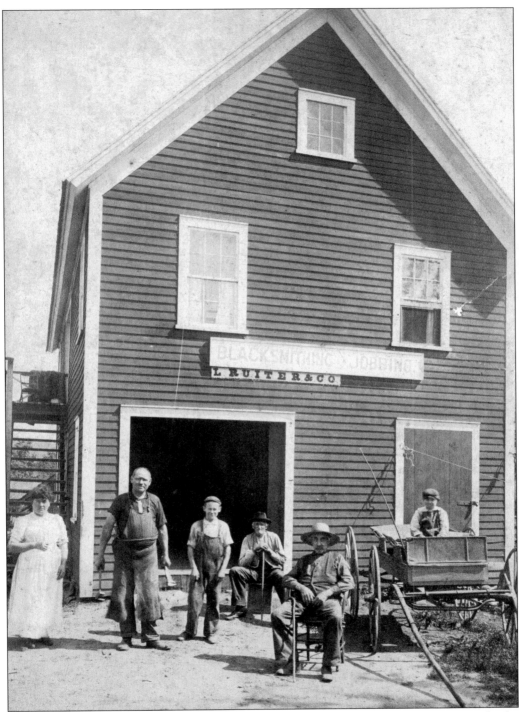

L. Ruiter Company's blacksmith shop stood on South Main Street, now 105 Somers Road. The family lived on the second floor. Pictured here is the Ruiter family. The forge was operated in conjunction with the teams and wagons employed by Frank Champlin.

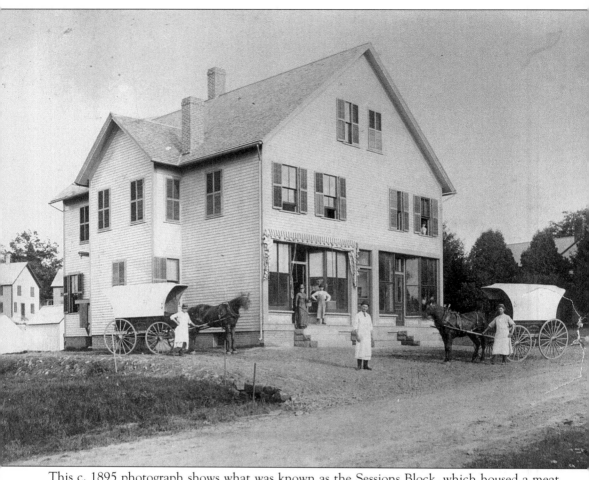

This c. 1895 photograph shows what was known as the Sessions Block, which housed a meat market for many years. The building stood just north of the center of town on Prospect Street.

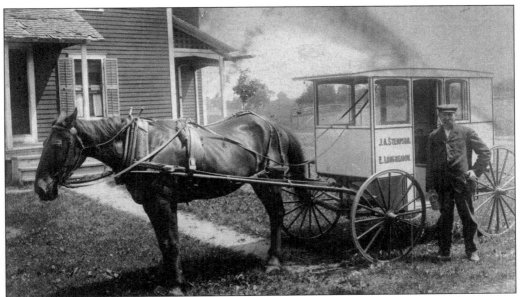

J.A. Stempson poses with his horse and milk delivery wagon. The horses were the primary transportation for milk wagons into the 1940s. A milkman would deliver to one stop, and the horse would meet him at the next stop.

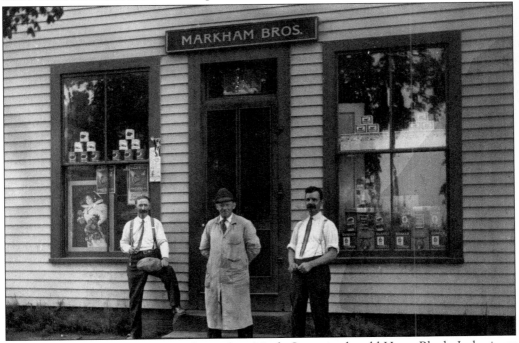

The Markham Brothers Store was located on Maple Street in the old Hunn Block. In business from 1908 until 1927, the Markham Brothers took grocery orders in the morning and made deliveries in the afternoon. The delivery service covered the area from Sixteen Acres to Baptist Village. This photograph was taken *c.* 1915. From left to right are Eugene Markham, Wallace Markham, and an unidentified man.

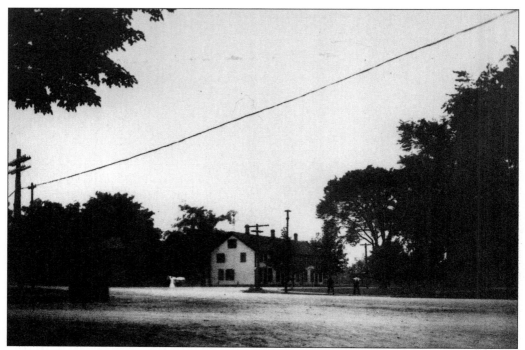

The Hunn Block is pictured here on Shaker Road. The W.H. Hall store is to the left. It later became Nooney's Hardware and was known as the center of business in the village.

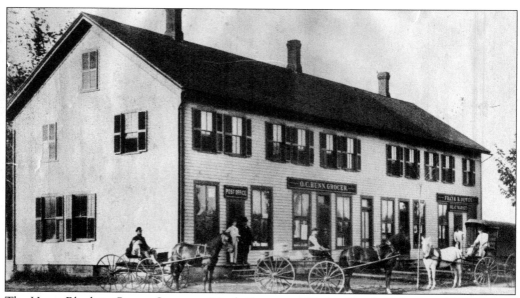

The Hunn Block in Center Square at Maple Street and Shaker Road was built in 1882. Shown here at the post office are Arthur F. Crane, clerk, and C. Hunn, postmaster. Frank Dewey is in the door of the meat market. The Hunn Block was demolished in 1947.

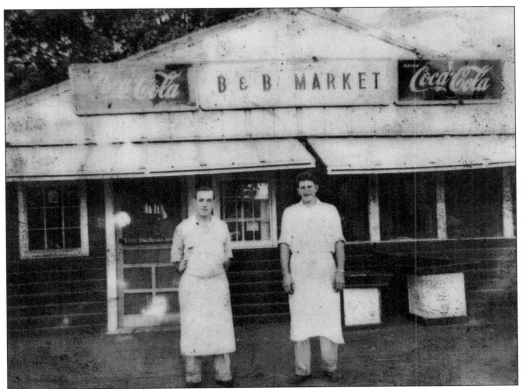

The B&B Market is seen here on July 5, 1953. Maurice Brault is standing to the left and Robert Bean is standing on the right in front of their newly opened business. They took over Ernest Ferrero's fruit stand and grocery store at 19 North Main Street.

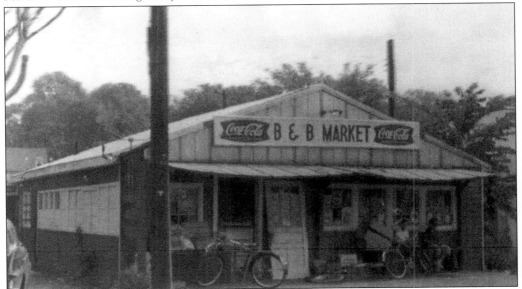

This 1958 photograph shows Tom Sawyer and Bill Donovan outside the B&B Market. Many children enjoyed their large selection of penny candy.

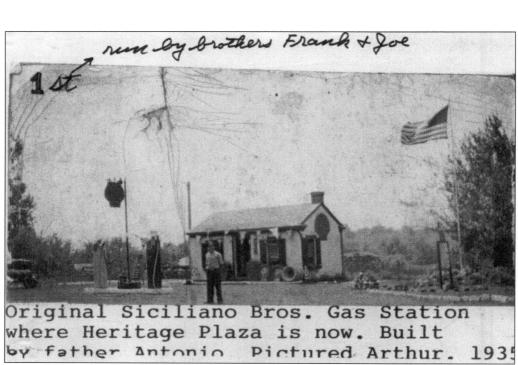

run by brothers Frank & Joe

1st

Original Siciliano Bros. Gas Station where Heritage Plaza is now. Built by father Antonio. Pictured Arthur. 1935

Father Antonio built the original Siciliano Brothers gas station in 1935. Arthur Siciliano is pictured here. The station was run by brothers Tom and Art. This building was torn down when Brockway-Smith was built, which was subsequently replaced by Heritage Shopping Plaza.

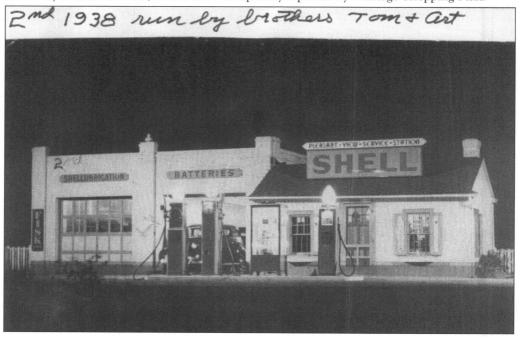

2nd 1938 run by brothers Tom & Art

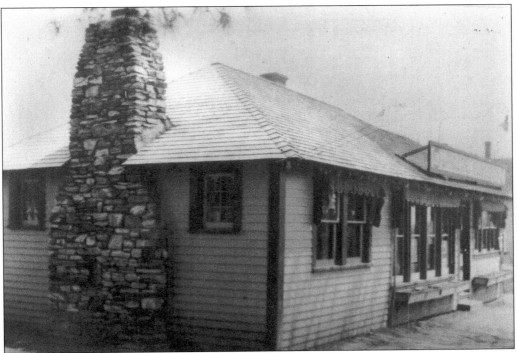

Countryside Store, located at 334 Somers Road, first opened as a gasoline station in 1926 and was known as "Laviolette's filling station." Shortly after that, the store started selling cigarettes, candy, soda, ice cream, and food. In 1941, Ida Clark purchased the property, closed the gas pumps, and renamed the restaurant-store Countryside Store. The old store was torn down in 1987 to make way for a larger facility. The Calabrese family currently owns it. The original store is seen above in a 1930 photograph.

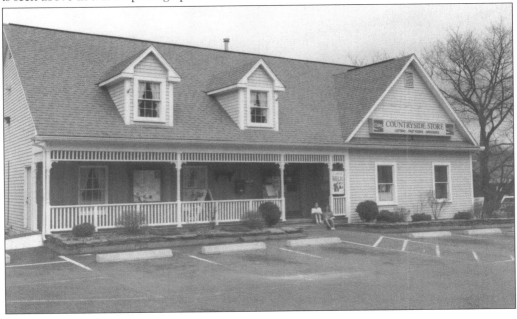

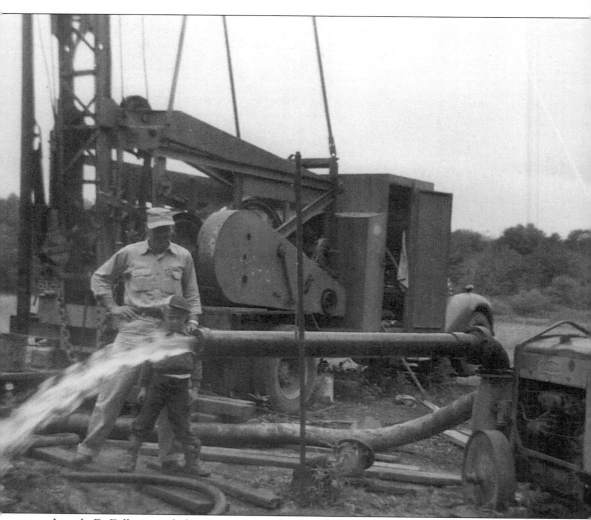

Joseph F. Dilk started the Connecticut Valley Artesian Well Company in July 1950. The original company was bought in part from Dilk's father-in-law, Howard A. Becker, when he retired. Becker had been employed by Frank A. Champlin in the early 1900s. Shown here are Joseph F. Dilk and son, Joseph F. Dilk III, in 1955.

Joan Anderson Earnshaw is seen here in the center of town in 1947. Notice the building in the background, as well as the memorial flagpole and the period automobiles.

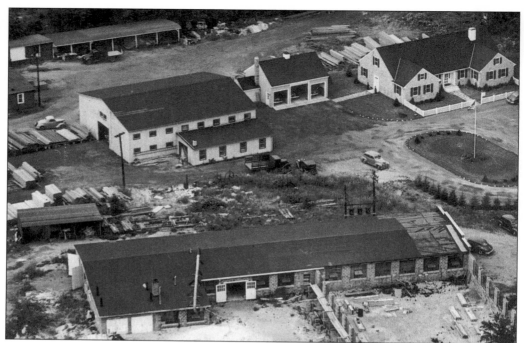

The foreground of this 1949 photograph shows an addition being put on the Sessions Casket Company on Shaker Road. The lumber for manufacturing caskets was received at this location. However, the remainder of the company was located in Springfield at the former Duckworth-Chain building on Mill Street. Eventually, the entire production was moved to East Longmeadow. Hampden Engineering took possession of the building in 1960. Forest Product Company is visible in the background, as well as the Gielco Wholesale Company, which also moved from Springfield.

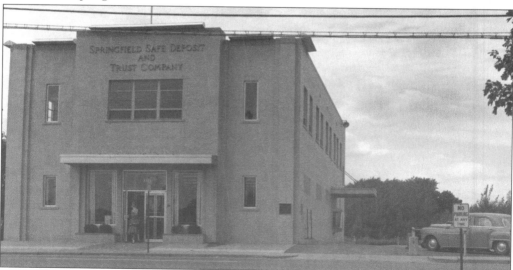

The new building for the Springfield Safe Deposit & Trust Company is seen here in 1957 at 31 Maple Street. This was the first bank to move into town. It later became the Shawmut First Bank, before closing altogether.

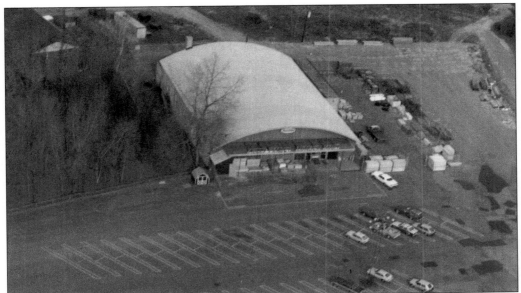

In 1950, Lloyd Fradet and Red Weeks purchase the Carmel Lumber Company in East Longmeadow to expand the Kelly-Fradet Lumber Company. Four people with a pickup truck learned how to operate a lumber business by trial and error. Over the next few years, the owners made several other purchases—the Enfield Lumber Company in 1957, the Broad Brook Lumber Company in 1963, and the Thompsonville Lumber Company in 1965. In 1974, the Kelly-Fradet Lumber Mart was complete. Ten years later, they purchased what is now the Ellington Kelly-Fradet Lumber Company, and added on another base in Hazardville, increasing the total chain to eight locations. The company caters to homeowners, general contractors, builders, and remodelers on all jobs large or small.

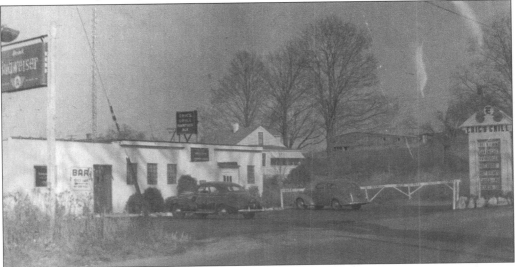

Eric's Grill, at the corner of Shaker Road and Chestnut Street was owned by Eric and Florence Zepke from 1946 until 1956. It was also known as Country Corner's Bar and Restaurant, and was a favorite eating place for Package Machinery employees. The business has since been torn down.

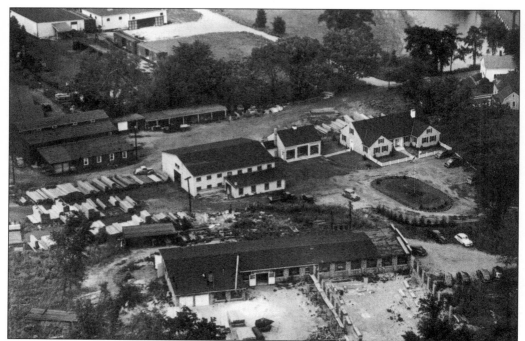

This is a 1948 aerial view of the Forest Product Lumber Company. The Community Feed Store is in the background and the Sessions Casket Company can be seen in the foreground with an addition in the process of being built. The Sessions Casket Company moved to East Longmeadow from the Duckworth Chain building on Mill Street in Springfield. When the business closed in 1954, the building was bought by the Hampden Engineering Company.

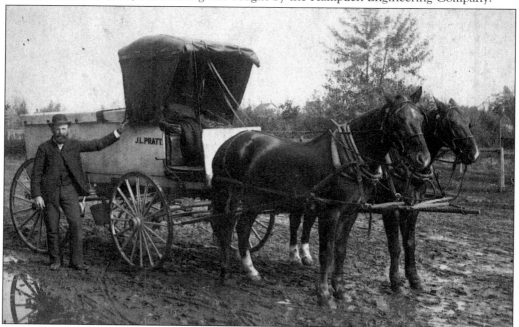

Shown is J.L. Pratt, who operated a delivery service in Springfield and East Longmeadow.

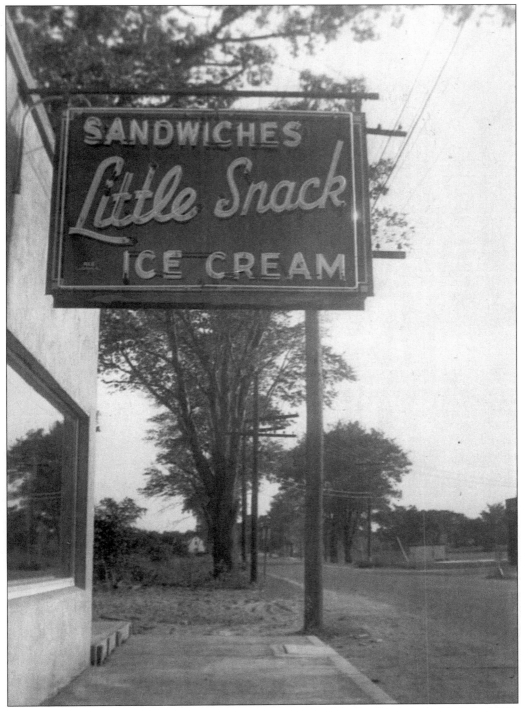

The Little Snack sandwich shop on Shaker Road was owned by Joe Lapardo in 1949. In 1957, the name was changed to Koffee Tyme, and it was moved to its current location. Mike Lapardo took over the operation in 1963, followed by Ernie Lapardo in 1968.

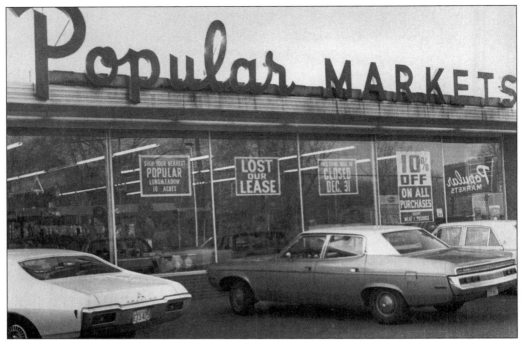

The Popular Market opened in 1956 on 28 North Main Street. This supermarket was part of a large chain of stores, which closed in 1971. Later, it became Rocky's Hardware.

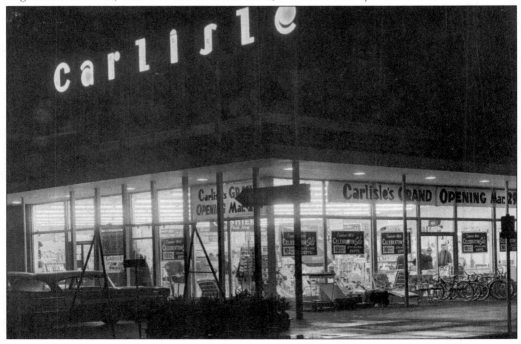

The Carlisle hardware store on Maple Street at Center Square was built on the former Leo Glynn property in 1961. The business closed in 1963 and was purchased by the town in 1964. It was remodeled and used for the town library in 1966.

This building was built by the government in the early 1940s to build engine parts for Pratt & Whitney of East Hartford, Connecticut. The Package Machinery Company moved into the 9-acre plant on Chestnut Street on December 6, 1946, from its previous facility on Birnie Avenue in Springfield. Its major product was wrapping machines and Reed Prentice Division plastic-injection molding machines. Milton Bradley currently uses the plant building for storage.

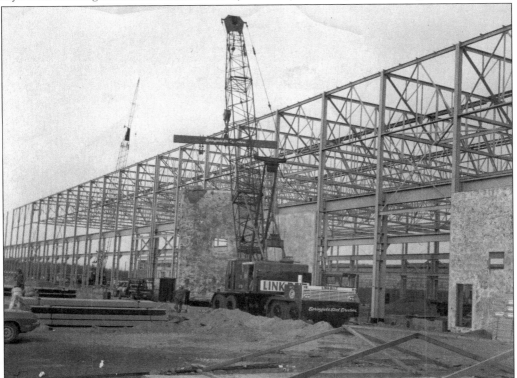

In 1970, the Package Machinery Company put an addition onto the original building. This photograph shows a large crane from Springfield Steel Erectors lifting the precast concrete into place.

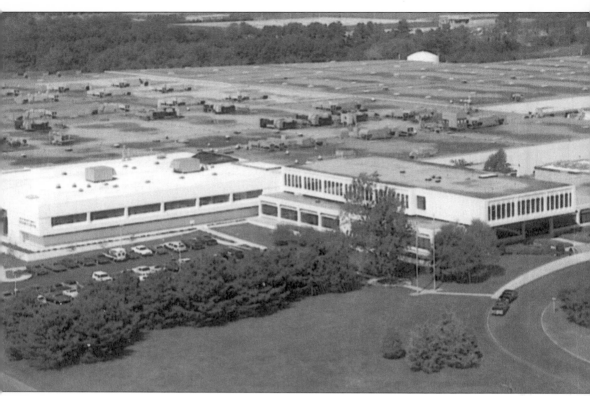

In 1858, Milton Bradley came to Springfield and started his own business as a draftsman in a small office at 247 Main Street. Two years later, he purchased a lithographic press. One of his first lithographic prints was of Abraham Lincoln without his beard and just after he was nominated for the U.S. presidency. The next product was the Checkered Game of Life. During the Civil War in 1861, Bradley worked as a drafter at the Springfield Armory. In 1880, he began making jigsaw puzzles. Revolutionary to the industry, the first paper cutter for the puzzles was developed by Bradley in 1881. The company continued to grow, and later that year a new five-story building was built at Cross and Willow Streets, to be followed in 1882 by a second five-story building. In 1891, a third building opened; it soon became necessary to open branch offices across the country. The first crayons were made in 1989. In 1909, another building was opened on Cross and Willow Streets. Bradley went on to become one of the largest makers of games and toys in the country. In 1962, ground was broken for the present multimillion-dollar plant and office facility in East Longmeadow. In 1984, Milton Bradley Company, and its subsidiary, Playskool, was acquired by the toy manufacturer Hasbro Industries Incorporated of Pawtucket, Rhode Island.

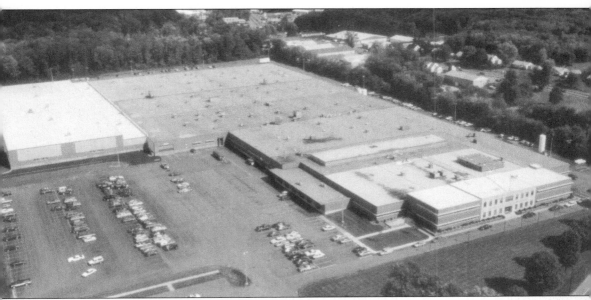

Founded in 1915, the American Saw and Manufacturing Company has long been owned by the Davis family and recognized worldwide for quality and customer satisfaction. Today, the company is committed to supply chain management (SCM), possibly its greatest undertaking. Through SCM, American Saw is redesigning processes to meet future customer needs.

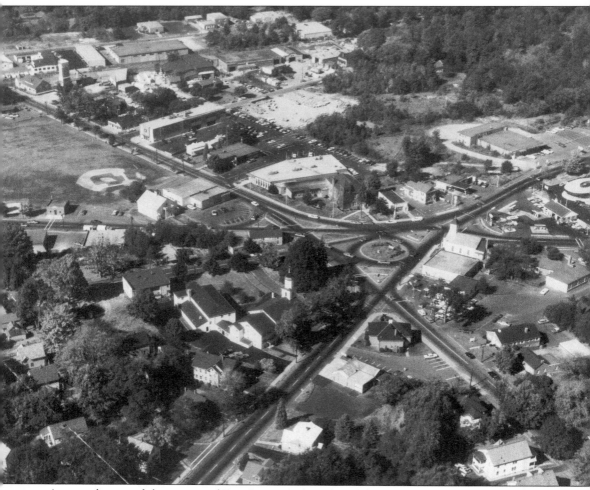

An aerial view of the center of East Longmeadow shows the town in 1968. The road pattern has been the same for many years, and this famous seven-road intersection is in *Ripley's Believe It or Not.*

Six

THE CENTER OF TOWN

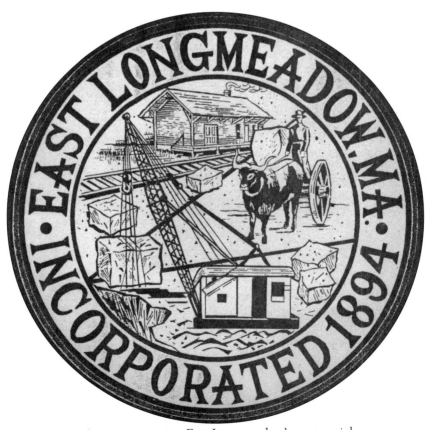

Shown is the town seal commemorating East Longmeadow's centennial.

Center Village is seen here in 1890. The Methodist church is on the left, the Congregational church is in the background looking up South Main Street and Prospect Street. Henry Hall's store to the right. To the right is the fence that went around the Crane estate.

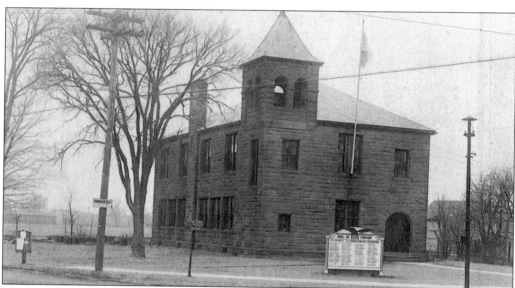

The town hall and schoolhouse were built in 1882. The first floor consisted of two large school rooms and a sizable anteroom for putting aside dinner pails, hats, and coats. The first town meeting was held in the newly completed second floor auditorium on April 3, 1882. This is how the building looking during the World War I. The honor roll board lists those that served in the military.

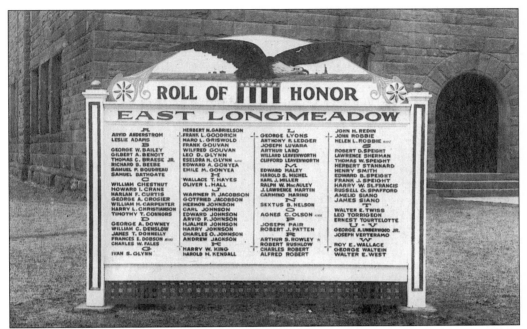

The Roll of Honor in front of the town hall was donated by the Women's Community Club, which was founded in 1917. The honor roll commemorated the 86 men and women who served in WWI. Only one was killed in action. When the rotary was reconstructed, the Roll of Honor was removed.

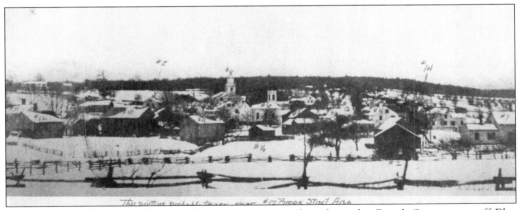

This photograph of East Longmeadow's center was taken from the Brook Street area off Elm Street looking southwest. The numbers identify the building or location when the picture was taken *c.* 1900. They are as follows: No. 1, the T.W. Speight house; No. 2, the T.W. Speight barn; No. 3, the Cadwell house; No. 4, the Graves house; No. 5, the Graves barns; No. 6, the Methodist church; No. 7, the W. Crooks Tavern; No. 8, the Congregational church; No. 9, the Oren Coomes barn; No. 10, the John S. Beebe barns; No. 11, the Methodist parsonage; No. 12, the Methodist parsonage barn; No. 13, Hall Hill Road; No. 14, the E. Cope House.

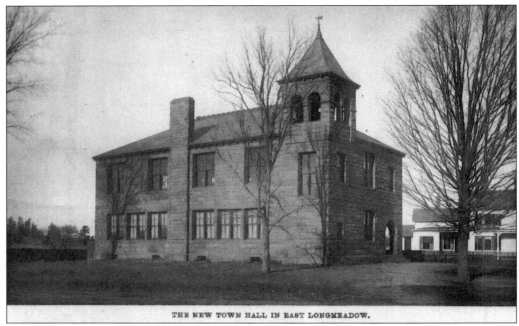

THE NEW TOWN HALL IN EAST LONGMEADOW.

This is the first photograph taken of the new town hall shortly after it was built in 1882. It was constructed with East Longmeadow brownstone by the Norcross Brothers Stone Company at a cost of $7,000.

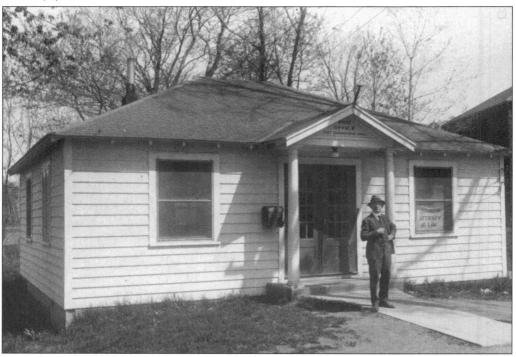

This 1934 photograph shows Leo Glynn in front of the post office and his law office on Maple Street (his second building). Glynn was the postmaster and, for many years, a selectman.

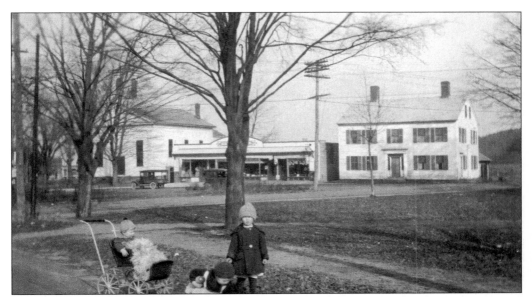

The Old William Crooks Tavern was built c. 1775 on the east side of the center rotary where the Pride gas station is now located. The tavern was a famous hostelry when East Longmeadow was on the stagecoach route between New York and Boston. The tavern and inn is said to have been used by Revolutionary War soldiers as they passed through town. A portion of the building was used by Seth Taylor, the first postmaster in town during the administration of Andrew Jackson. The tavern was converted into a residence during the latter part of the 19th century, when it was owned by S.J. Cormiel. The old tavern building was demolished in 1929.

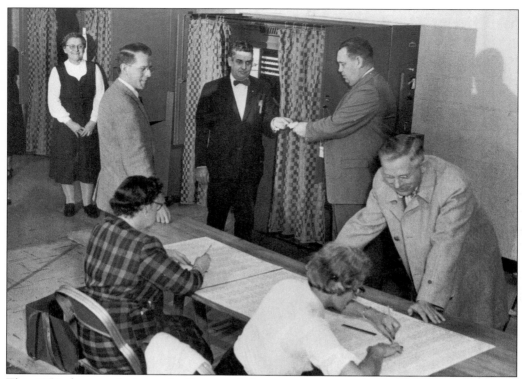

This 1958 photograph shows the first use of electronic voting machines in the area. Selectman Sherwood Cronk casts the first ballot. Others include Kenneth Malustrom, Art Anderson, and Richard Clark.

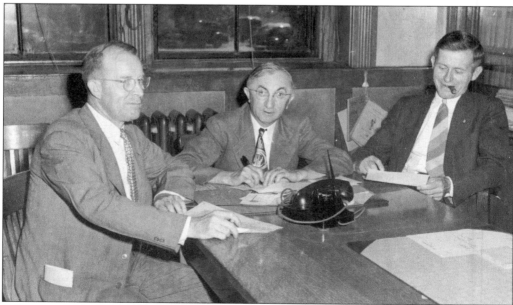

Selectman John E. O'Toole, chairman Leo D. Glynn, and Arthur W. Anderson are pictured here in 1944 at their weekly meeting in the corner office next to the town clerk's office.

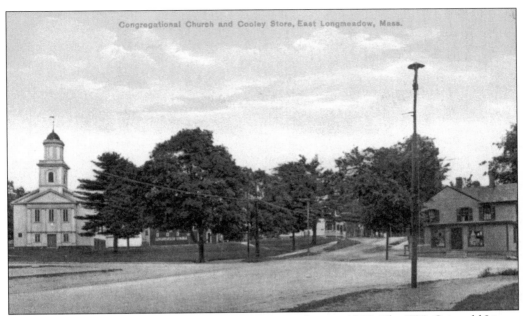

The Congregational church and Cooley Store are seen here in 1910. The W.J. Griswold Livery & Feed Stable is located to the right of the church.

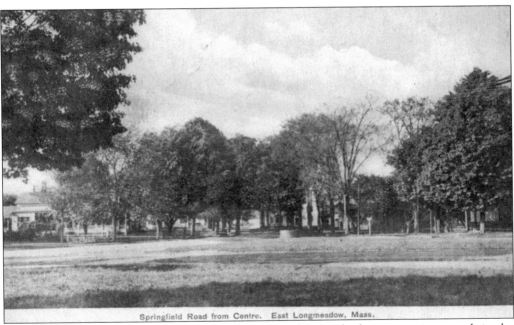

A 1910 photograph shows the famous rotary. Notice the circular horse watering trough in the middle. Navigation through the seven crossroads was certainly easier in those times. The Methodist church is at the far right and the Crane house is at the far left.

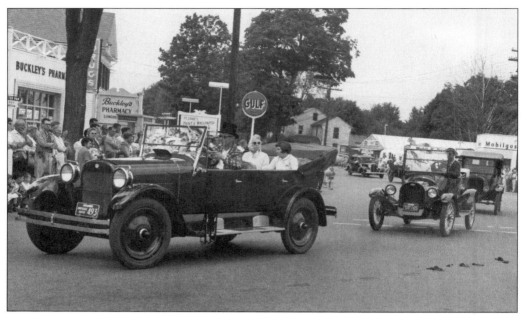

The Fourth of July parade in East Longmeadow is truly a tradition dating back many years. This photograph of the antique cars in the parade was taken in 1961 from the rotary looking north with Buckley's Pharmacy, Plumbs Paint and Wallpaper, the Gulf station, B&B Market, and Mobil station in view.

This photograph shows the 1971 Fourth of July parade going through the center of town. As you look from the war memorial toward Maple Street, you can see the Big Ben Restaurant on the left and the grain tower in the distance on the right.

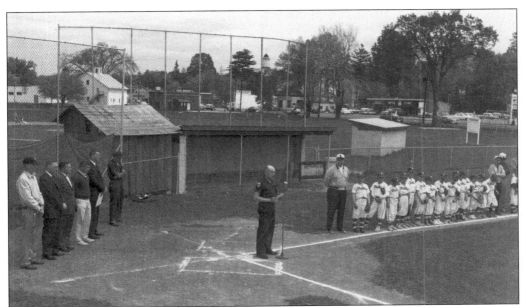

The Charles Turner League was dedicated in 1961 at the little league field. Marshall Hanson is standing at the microphone.

This image of Maple Street looking west near Edmund Street was taken in 1952. Large maple trees lined the street from the center out. The sign on the right reads, "Busy B Pre School," which operated out of the house on 89 Maple Street. A milk delivery truck can be seen making its rounds.

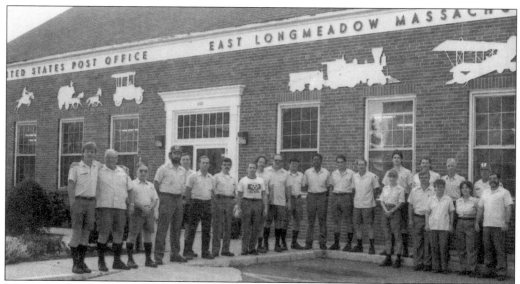

The post office building at 100 Shaker Road was completed and dedicated on May 1, 1963. It was closed on August 24, 1992, when the post office was moved to a state-of-the-art building at 119 Industrial Drive. More than 100 employees deliver to more than 18,500 delivery points in East Longmeadow, Longmeadow, and parts of Springfield.

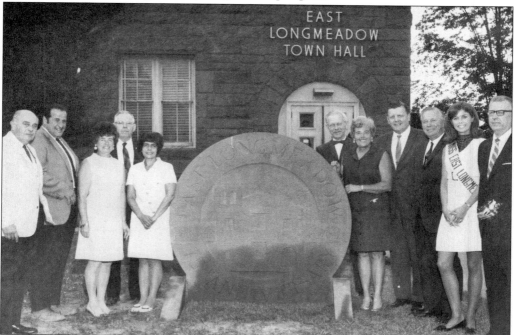

This stone commemorating the town's 75th anniversary was made by the McCormick Stone Company of East Longmeadow and was dedicated in June 1969. Pictured, from left to right, are Douglas Beck, designer; Strati Chipouras; Ina Bremmer; Sanford Nooney; Mary Woods; Arthur Anderson; Jane Hickey; Dick Hickey; John Lundgren; Sally Benoit, Miss East Longmeadow; and William Finnegan.

Seven

TRANSPORTATION

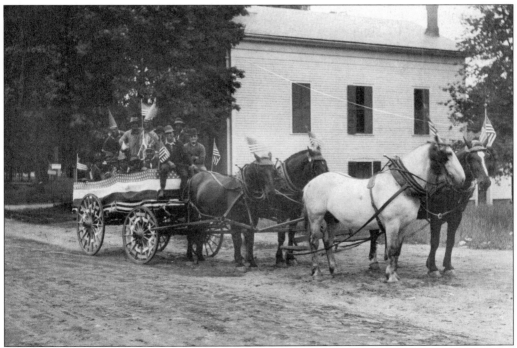

This July 4, 1914 photograph shows a four-horse team pulling a loaded wagon at the center of town in front of the Methodist church. Note the unpaved road.

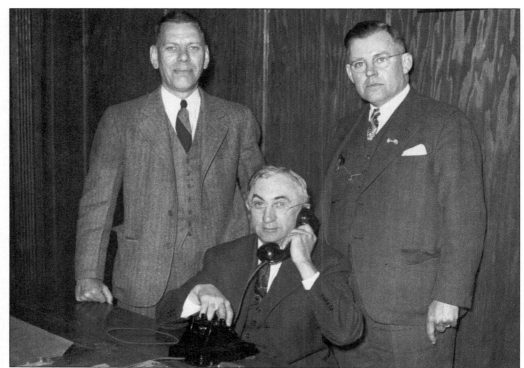

The automatic dial system installed by the New England Telephone and Telegraph Company went into operation in 1940. Chairman of the board of selectmen Leo Glynn, center, is shown dialing the first number on the new instrument in the town hall. At right is selectman Sanford P. Nooney, and Carroll Parker, NET&T manager, is on the left.

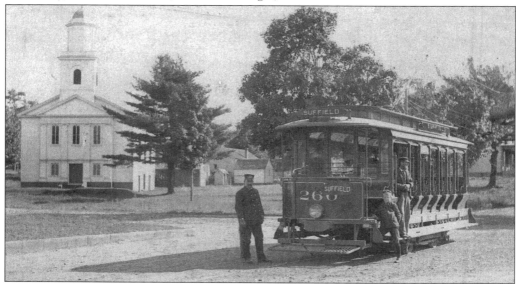

This trolley line, shown in the center of town, connected with a line to Suffield, Connecticut. The Congregational church is in the background. The trolley came to East Longmeadow in 1902.

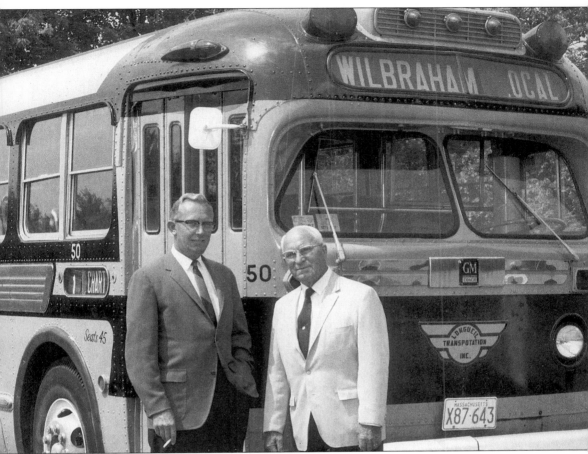

Pictured at the Longueil Transportation Terminal at 144 Shaker Road in 1962 are Paul Gardell (left) and Roy Longueil. It was common at one time to see the bright yellow school buses of Longueil transporting children throughout East Longmeadow. Roy J.S. Longueil started his company in 1932 by investing $275 in one bus and driving it himself. The company grew several times over the years. Longueil was a pioneer in the hiring of women and minorities. During a shortage of qualified male drivers, the company took the bold and unprecedented step in 1957 to train five women, all of whom were married and mothers of school-age children, to operate the buses in Springfield. Women have been an integral part of the business ever since.

At the height of business, Longueil operated a fleet of 125 vehicles with 165 employees. Charter rights included all of North America. They also operated several PVTA line runs from Springfield to the surrounding suburbs. Shuttle service ran to the airports in New York City on a daily basis. Atlantic City and Plainfield Greyhound line runs were instituted as well. Several local companies contracted to have their employees transported also. School bus service was provided to Springfield, Longmeadow, East Longmeadow public and parochial schools.

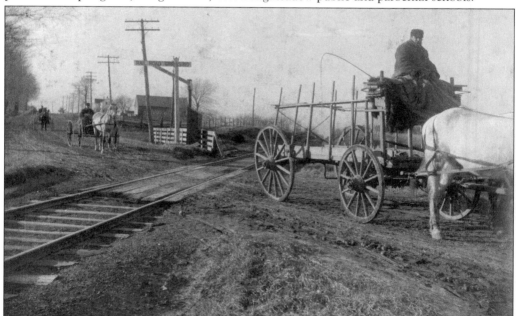

The Robesen Crossing on North Main Street is seen here in 1897. In 1901, the crossing had a dry bridge built over it when the town requested the Springfield Street Railway extend the trolley line into East Longmeadow. In 1902, the trolley arrived in East Longmeadow. Since the tracks are no longer in use, the bridge is scheduled for demolition.

The East Longmeadow railroad station was built c. 1875. The line was known as the Highland Division of the New York, New Haven, and Hartford Railroad. The railroad station's first stationmaster was Edwin H. Coomes. Upon his retirement, his son took over, following in his father's footsteps. After his retirement, Jay E. Traver Sr. took over as stationmaster until 1944. A part-time railroad representative then took over until 1950, when it closed. When the quarries were in full operation, there were two passenger and two freight trains passing through East Longmeadow each way daily. In 1890, some 25,147 tons of stone were shipped out.

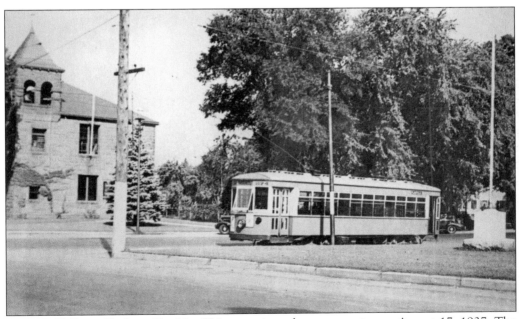

Springfield Street Railway Car No. 574 comes into the town center on August 17, 1937. The town hall is in the background on the left.

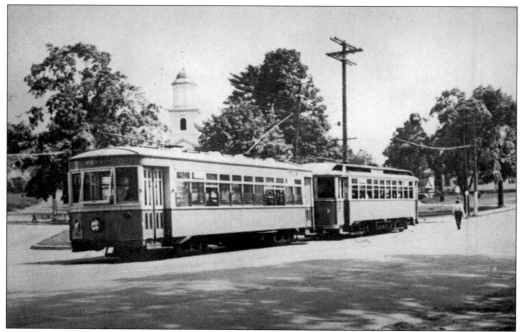

Two Springfield Street Railway cars, No. 591 and No. 475, get ready to leave the town center in this June 11, 1939 photograph. About two months later, buses replaced the streetcars.

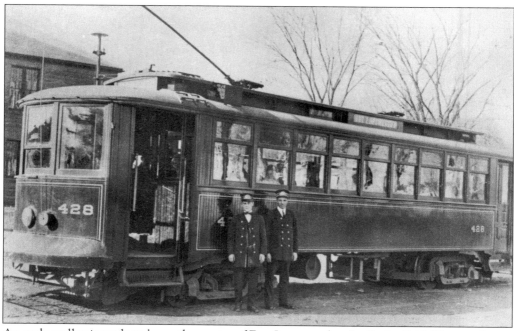

An early trolley is ready to leave the center of East Longmeadow for Springfield. The conductor is Ray Daly. The town hall can be seen in the background in this 1916 photograph.

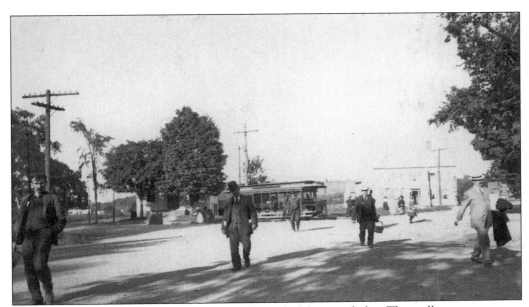

The open trolley brings home passengers at the end of their work day. The trolley came to town in 1902. With rapid changes, including the decline of the quarry industry, business slowed. This picture was taken from the corner of Maple Street and Shaker Road, looking east. The tavern is also shown in the background. The man in the derby hat and suit in the center of the picture is Frank A. Champlin, a driller known for his artesian wells.

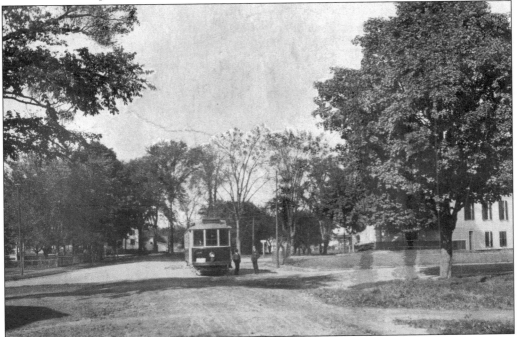

This 1910 photograph of the trolley at the center of East Longmeadow was used to produce one of the many postcards of the town. This view looks north across the intersection to North Main Street. The Methodist church can be seen on the right.

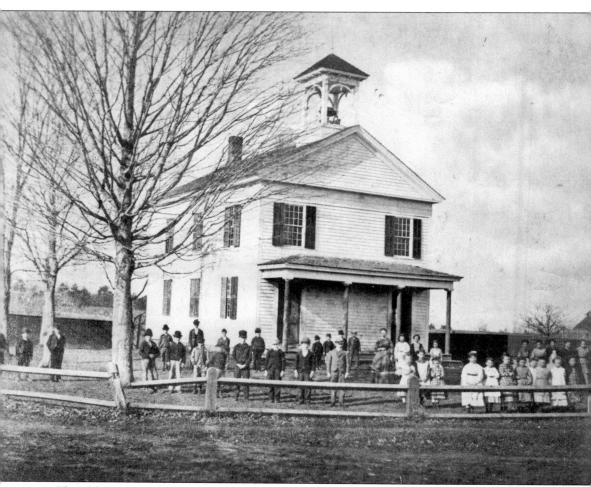

The old Center School is seen here, c. 1881. Helen Twining and her pupils pose at the school located on the present town hall lot. In 1882, the school was moved to Center Common; several years later, it was moved to the site where Dr. Rohr's house now stands on Somers Road. The town hall was completed in 1882 at a cost of $7,000. According to the town vote, the building was to contain "suitable rooms for school purposes."

Eight

SCHOOLS AND FARMS

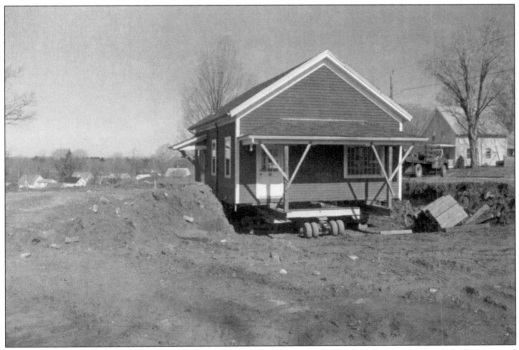

The Little Red Schoolhouse, seen here from the corner of North Main Street and Westwood Avenue, was moved to the former Center School site at High and School Streets in 1994. This photograph shows the building shortly after it was moved and before the foundation was poured.

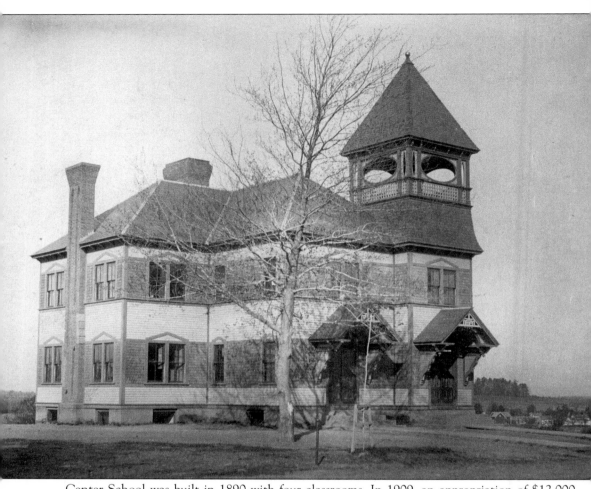

Center School was built in 1890 with four classrooms. In 1909, an appropriation of $12,000 added four more rooms, a project that was completed in 1912. It was not until 1929 that they had inside toilets. From 1918 to 1920, all seventh and eighth grades attended this school.

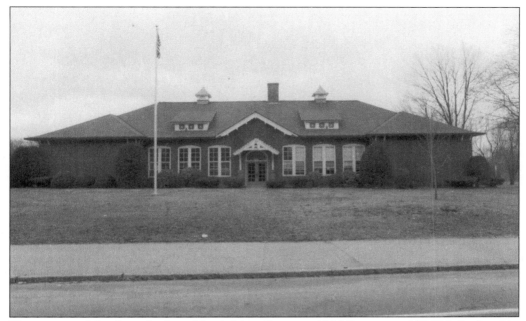

Pleasantview School was built on North Main Street in 1916 for a cost of $9,990. It closed in 1969. The building is currently used by the East Longmeadow Recreation Department and Council on Aging.

Hall Hill School near the corner of Pease Road and Prospect Street was closed in 1926 and the pupils were then transported to Center School. In 1929, the school was sold to Mrs. Signe Malone for a private home.

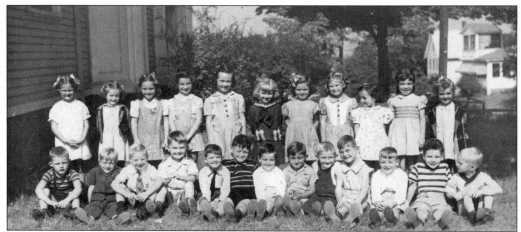

This photograph shows the Center School's first grade class in September 1943. The teacher was Marie Kerson Forcier. Shown, from left to right, are the following students: (front row) Garnder Yeomans, Ralph Meyers, Charles Frey, Stephen Allen, Clifford Redin, Robert Sussman, Robert McCarthy, Robert Richards, Ronald Premo, Peter McCarthy, Robert Lindstrome, William Speight, and Robert Knowlton; (back row) Doreen Dibble, Betsy Austin, Marion Thresher, Judith Cotter, Mary Rintoul, Carolyn Bilton, Noreen Turnberg, Mary Lou Markham, Peggy Ann Kenison, Sandra Hazen, and Teresa Isham.

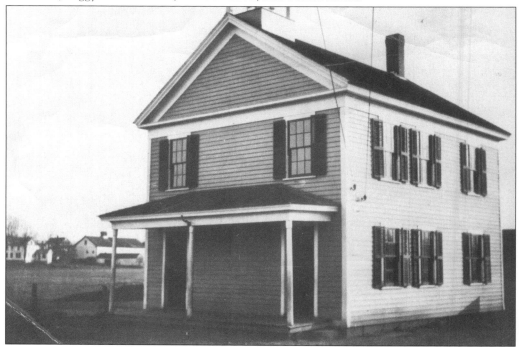

The Baptist Village School was located on Meadowbrook Road. Grades one through eight were taught here in one classroom. The teacher also served as the janitor. The school was closed in 1930 and all the pupils were transported by bus to Center School. Baptist Village School was demolished in the early 1930s. Meadowbrook Farm, formerly the Emil Hahn farm, can be seen to the left in this 1913 photograph.

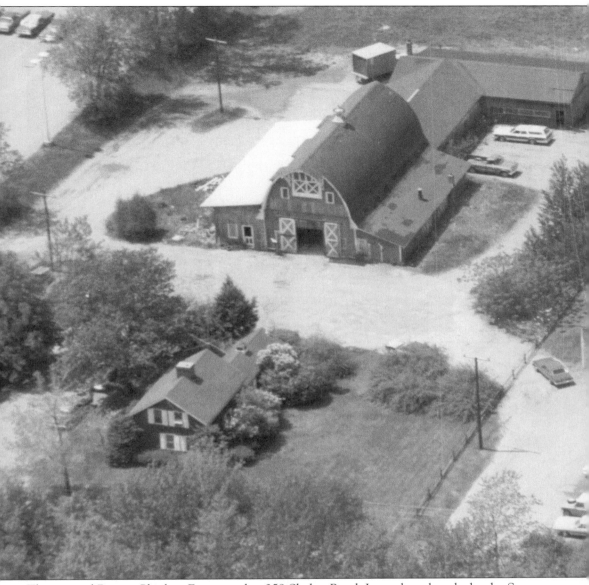

The original Rogers Chicken Farm stood at 359 Shaker Road. It was later bought by the Spear Construction Company in the early 1950s and operated as Builders Supply. The building was subsequently sold to the Suburban Cabinet Shop, owned by James Davis and Richard Redin, in 1960. This building was converted to a deli and restaurant for several years in the mid-1990s. It later became a meat market for Arnold's Meats. This photograph was taken in 1970.

The Ashley Farm at 1 Porter Road is seen here in a 1901 Howe Brothers photograph. The house was built in 1805 and still exists today, although all the farm buildings are gone.

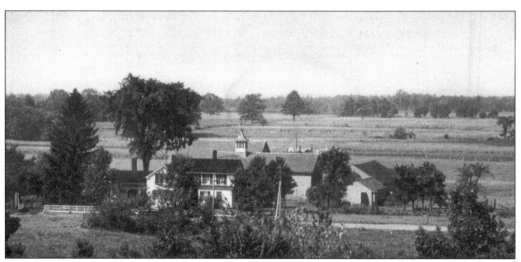

This farm was located one mile south of East Longmeadow center on Shaker Road. It was purchased c. 1861 by Samuel H. Ellis, who moved here from Gilead, Connecticut. Only the southern half of the house had been built at that time. A portion of the land was bought from the Shakers of Enfield, Connecticut. It was wooded and was cleared for farming using oxen. Samuel Ellis' son, Edward S. Ellis, completed the house at the time of his marriage and took over the operation of the farm, naming it the Clover Lawn Stock Farm. He maintained a herd of purebred Shorthorn cattle and developed a special strain of popcorn, growing 20 acres each season.

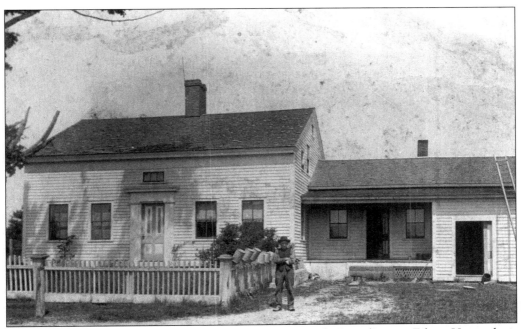

The Daniel Hancock house is seen here on Porter Road. Daniel's son, Ethan Hancock, is standing in front of the house. He later became a member of the town's school committee. The house is still a residence today.

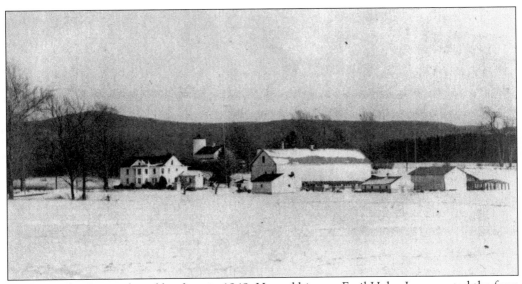

Emil C. Hahn Sr. purchased his farm in 1949. He and his son, Emil Hahn Jr., operated the farm with over 80 milking cows. The milk produced was sold wholesale and retail, serving about 600 customers. Before the Hahn ownership, the farm was owned by the Dwight family for about 100 years. The farm was sold to John Burney in 1996 and renovated into a market garden business.

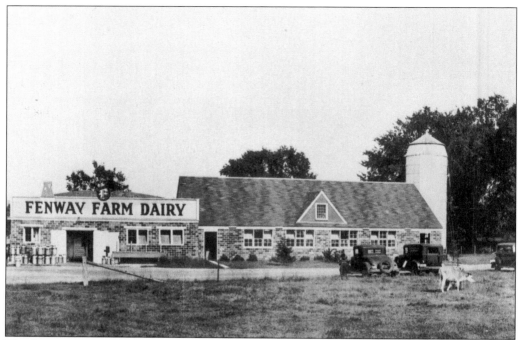

The Fenway Farm Dairy was located at the northwest corner of Allen Street and Porter Road. This 1937 photograph shows part of the 70-acre farm, purchased in 1931 by Olin M. Fisk and his father, George E. Fisk. Today, Fenway's Golf is operated there by the third and fourth generations of Fisks.

The Fenway farmhouse at the corner of Allen Street and Porter Roads is shown here. The Fisk brothers built their own houses on the property and rented out the original farmhouse.